CIPHERS

CHRISTOPH GIELEN

CIPHERS

CHRISTOPH GIELEN

jovis

GEOMETRIC SOCIOLOGY

In his classic novel *The Crying of Lot 49*, Thomas Pynchon describes a suburb that is "less an identifiable city than a grouping of concepts—census tracts, special purpose bond-issue districts, shopping nuclei, all overlaid with access roads to its own freeway." The novel's protagonist, Oedipa Maas, drives down into this Euclidean city of rough-edged shapelets, only to find with no real surprise that "nothing was happening" there.

She "looks down a slope, needing to squint for the sunlight, onto a vast sprawl of houses which had grown up all together, like a well-tended crop, from the dull brown earth," Pynchon writes, "and she thought of the time she'd opened a transistor radio to replace a battery and seen her first printed circuit. The ordered swirl of houses and streets, from this high angle, sprang at her now with the same unexpected, astonishing clarity as the circuit card had."

The architectural system unfolding in front of her held, according to Pynchon, a "hieroglyphic sense of concealed meaning, of an intent to communicate." Indeed, looking downhill at these fingerprint-like whorls and acute angles of a now-absent intelligence, Oedipa experiences an "odd, religious instant."

Glyphic, abstract, and typological, German-born photographer Christoph Gielen's aerial studies of suburban land-use patterns range from the multidirectional universe of ribbons in the highway structures of Southern California to kaleidoscopic rosaries of Arizona houses. In his own words, Gielen "specializes in conducting photographic aerial studies of infrastructure in its relation to land use, exploring the intersection of art and environmental politics."

Gielen approaches his chosen locations by helicopter, performing what he describes as "meditative moves" in the sky, hovering above these sites distinguished by their absolute clarity: they are boxes, loops, labyrinths, and half-circles, exaggerations of the desert topography they are surrounded by.

His prison photographs must be made quickly, Gielen explains, snatched during the aerial equivalent of a drive-by—otherwise identification marks on a lingering helicopter tail might be noted by prison officials and questions would inevitably result. His visits are thus precise, permissionless, and oddly guerrilla, though satellite views of the very same places remain easily accessible to the public.

Through Gielen's lens, outdoor exercise yards become nothing more than cages, cramped prostheses on the backs of the prisons proper; whatever freedom or physical excitement such spaces were meant to offer looks appropriately absurd from such heights.

For Gielen's suburban missions, on the other hand, his method is to start with maps, surveying the landscape county-by-county until the right, optically provocative geometries are found. To zoom in further on these arranged environments, he visits them by car, touring the sites with a real estate agent to gain insight into the neighborhood's aspirations: how it sees itself, or, at least, how it is portrayed in the marketing pamphlets and sales pitches of local residents.

Far from humanizing the subject, this adds a further layer of abstraction: the landscape's aesthetics, or lack thereof, become economic calculations. Gielen's interest in keeping these locations anonymous only furthers this alienation. It is an encounter in the most literal sense: a forensic confrontation with something all but impossible to comprehend.

The Sun Belt suburbs depicted in these images are "absolutely self-contained," Gielen suggests; "many of them," he adds, are "not changing anymore." They are static, crystalline and inorganic. Indeed, many of these streets frame retirement communities: places to move to once you've already been what you've set out to be. This isn't sprawl, properly speaking. They are locations in their own right, spatial endpoints of certain journeys.

The photographic results are often stunning, as these monumental earth-shields of anthropological sprawl reveal their spatial logic from above. Seemingly drab and ecologically disastrous—even culturally stultifying—suburbs become complex geographic experiments that, for all their initial ambition, perhaps didn't quite go as planned. Many of the photos—such as the triptych Sterling Ridge VII/III/VI Florida 2009—reveal something genuinely alien, more like conceptual studies for exoplanetary settlements as imagined in the 1950s by NASA.

How strange and deeply ironic it seems that a photographic project ostensibly intended to show us how off-kilter our built environment has become—Gielen writes that "he hopes to trigger a reevaluation of our built environment, to ask: what kind of development can be considered sustainable?"—reveals, instead, that the suburbs are, in a sense, intensely original settlement patterns tiled over the landscape in ways our species could never have anticipated.

We are living amidst geometry, post-terrestrial screens between ourselves and the planet we walk upon.

Indeed, looking at Gielen's work, it's tempting to propose a new branch of the human sciences: geometric sociology, a study of nothing but the shapes our inhabited spaces make. Its research agenda would ask why these forms, angles and geometries emerge so consistently, from prehistoric settlements to the fringes of exurbia. Are sites like these an aesthetic pursuit, a mathematical accident, a calculated bending of property lines based on glitches in the local planning code or an emergent combination of all these factors—diagrams of a new anthropology still waiting to be discovered?

Or are they the expression of something much deeper in human culture—some mystical spatiality of the global suburb, an emerging cult of a redesigned earth—like prehistoric glyphs only visible from high above?

Geoff Manaugh

WHAT WE CAN'T SEE FROM THE GROUND:
The Contribution of Gielen's Images to Climate Activism

*"...we have at our disposal modern techniques for seeing every-
thing, apprehending everything, yet we see nothing."*
 – Sophie Ristelhueber

UNTHOUGHT THOUGHT

Broadly speaking, there are two types of photographs: in-
formational and pensive. One is the rule and the other is the
exception. Nearly all photographs are comprehended in an
instant and assimilated into an existing store of knowledge,
cultural assumptions and beliefs. Even where the image is
partially inscrutable to a viewer, some supplemental infor-
mation is brought to bear so that ultimately the image whol-
ly supports and is supported by that textual supplement. In
fact, all informational photographs (which is to say nearly all
photographs in general) are subordinated to some text (i.e.,
a set of things we might say about them), whether that text is
implicit or explicit. The informational image confirms knowl-
edge and does not touch belief.

The pensive photograph is an exception. Such an image
comes to us like a memory, but not a memory of our own.
As Jacques Ranciere, who invented the term, describes it:
the pensive image "contains unthought thought, a thought
that cannot be attributed to the intention of the person who
produces it and which has an effect on the person who views
it without her linking it to a determinate object." To adopt
Ranciere's terminology wholesale, we can say that such im-
ages have a particular capacity to emancipate the spectator,
to operate in an unsettling way upon belief.

It would appear that a given photograph could not be both
informational and pensive at the same time, as the infor-
mational works against the pensive (because it is precisely
determinate) and vice versa. One orients and the other dis-
orients. However, there is no reason that a given image can-
not be used informationally in one context (or even at one
moment in the viewer's interaction) and then function in a
pensive state in another context (or when looked at in a dif-

ferent way). Christoph Gielen's aerial photographs are an
example of such images, particularly as they relate to the
discourse of ecology.

THE SKY IS FALLING

As pensive images, Gielen's photographs appear to be of the
ground but are actually of the sky falling.

And the sky is falling. For real this time. How do we know
this? It is not anything we can see. It is something we can
read: in the reports of the Intergovernmental Panel on Cli-
mate Change (IPCC) and countless other documents. De-
spite the misperception of the public that significant sci-
entific uncertainty persists, numerous surveys of relevant
peer-reviewed literature and of scientists' opinion in ap-
propriate fields have shown the count of qualified climate
change adherents to qualified climate change skeptics is
consistently about ninety-seven to three.[1] If ninety-seven
of the top financial analysts in the world advised selling a
stock or risk total ruin and only three were advising to hold
on to it (or that they weren't really sure what to do), and, in
the absence of real qualifications to perform an independent
analysis yourself, would you really risk holding on to that
stock? Likewise, ninety-seven doctors urging treatment and
only three advising against it—would you take that risk?

Because what do we non-specialists really know about cli-
mate change after all? Do we really know the sky is falling
as described in all this literature or do we "merely" believe
it? Properly speaking, climate change is the title given to a
composite interpretation of certain facts and measurements
(things that can be seen), and thus a proposition (however
valid) and not a fact itself. In the words of Birgit Schneider,
climate change is an "abstract, statistically created, long-
term research object."[2] Belief expresses a relation between
myself and a proposition, whereas knowledge expresses a
relation between myself and a fact. Seeing, therefore, con-
tributes to knowledge and not to belief—contrary to the pop-

ular adage. As climate change is a proposition, it is a ques-
tion of belief and cannot be seen. It must be transcribed on
top of sight. There are no photographs of climate change,
only those that point to it in one way or another. Some right-
wing commentators are perhaps right on this point: we be-
lieve in climate change (and have very good reason to). It is
a matter of faith.

Yet, the fortitude of that belief is exceptionally poor.
Michel de Certeau usefully defines belief as an investment in
a proposition. For de Certeau that investment is exhibited in
action.[3] Whatever our strength of belief concerning the sci-
ence of climate change, we exhibit a very weak belief overall,
as evidenced by our near total lack of action. We can read all
the documents, agree with them, understand their implica-
tions for global risk and building a sustainable society, but
not really come to terms with the reality of those projections,
the worst-case scenarios of which are traumatic in the full-
est sense of the word. Our ability to believe in climate change
(whatever we may know about it) is blocked by the thick wall
of the Normal. Slavoj Zizek explains this as follows: "our
attitude here is that of a fetishistic split. 'I know very well
(that global warming is a threat to the entire humanity), but
nonetheless I cannot really believe it. It is enough to see the
natural world to which my mind is connected: green grass
and trees, the sighing of the breeze, the rising of the sun...
can one really imagine that all this will be disturbed?'"[4]

Here we have a conundrum that Gielen's images and other
art can help us not so much to resolve as simply to get over:
climate change and other projective ecological calamities
can be seen but not really seen, known but not really known,
believed but not really believed. Surmounting barriers to
belief in climate change, even momentarily, requires some
negative capability.[5] A proposition can be as real as a fact and
climate change is as real as the undeniable force of its calcu-
lations of probability, which include the horror of extinction.
Once we get over the dangerously consuming and utterly

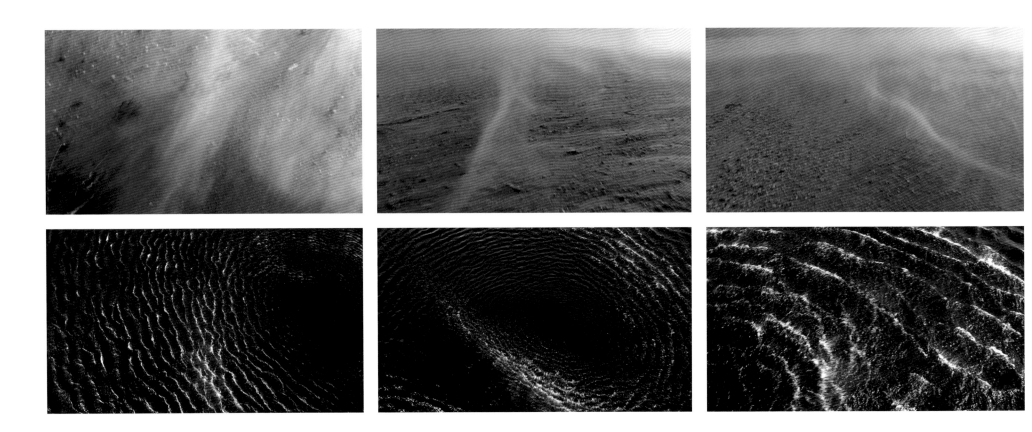

pointless debate about the "reality" of such calculations, we can get on with the urgent task of coming up with solutions. Gielen's work contributes to this process by prompting the viewer into a mode of active sight, and this is contingent on getting lost.

THE VALUE OF DISORIENTATION

Most of the time we do not choose to see. It just happens. We open our eyes and the world comes into them. So passive does this seem that we do not consider the constant stream of analysis that sight initiates and propels. As soon as we start receiving visual information—where is the wall, how bright is it, who is here with me—we start to use that information to make decisions. Should I get up, where should I put my foot, do I need to check the time, turn on a light, etc.? In the process of using sight to inform action, we are constantly relying on and reaffirming our notion of what is normal, to-be-expected.

Only when we look at something with a specific, self-conscious intent (including through memory) does the intrinsic relationship between sight and analysis become apparent.

In this active form, sight acquires the capacity to undo assumptions rather than contribute to them. Various forms of technology have augmented the ability of concentrated sight to contribute to such analysis, notably: the use of lenses to increase the range of our sight; the ability to situate a lens inside the human body or at a great remove from the surface of the Earth; and the fixing of such technological sight into documents that can be preserved and considered at length— i.e., photographs, x-rays, or remote sensing data. Such advances in technology have been truly momentous events in human history and have radically altered our notion of "the environment." So much so that, as Laura Kurgan has noted, "we do not stand at a distance from these technologies, but are addressed by and embedded within them."[6] What initially led to a readjustment of the Normal by pushing the boundaries of our senses is inevitably subsumed into its new construction, and the process must begin anew.

Because our selves grow into the technologies we create (à la McLuhan), images that might have triggered self-conscious analysis reflexively in the past are now simply regarded in the same passive way as our bedroom upon waking. This is

true of the aerial image, which has become a part of our everyday lives despite being profoundly unlike normal sight and an affront to photography's intimate relationship with subjectivity and memory. Formerly, aerial photographs seemed to belong to that class of images—such as x-rays, crime-scene photographs, and GIS data—that demanded specialist interpretation for their full meaning. Now, such views from above are summoned routinely by anyone with a smartphone and proceed to impose, without any definite malice, the "quiet tyranny of orientation" (Kurgan's words again).[7]

Orientation is tyrannical because it draws us like a tractor beam into the dominion of a single symbolic order, a single way of seeing. It is in this sense that, as Erroll Morris has suggested, belief actually precedes and informs sight, much more than the reverse.[8] Most of the time, this orienting is quite justified and even necessary. To question and re-consider every piece of visual information would utterly cripple us, rendering us like a character in a Borgesian meditation. However, it is a productive maneuver of the arts and other Humanities to urge us out of this standard mode of orientation when necessary so that we might consider an image

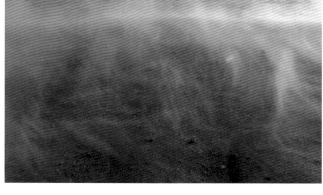
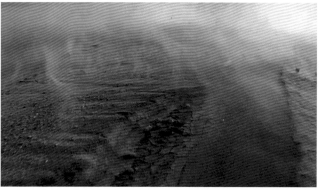
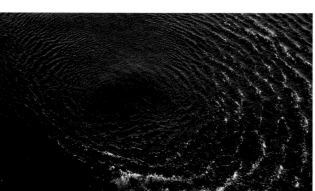
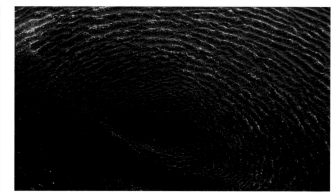

UNTITLED CALIFORNIA IV Video

UNTITLED CALIFORNIA III Video

or idea more deeply. Such slow, active seeing has the capacity to undermine assumptions that would not be examined within the type of speedy, information-driven images of Google Maps, most journalism, or just normal, everyday passive seeing.

THE TWILIGHT ZONE

Gielen's landscapes apply to the discourse of climate change because they challenge our comfort in the normal and break down deeply held beliefs at a particularly important point—the assumption that growth is unlimited and always beneficial. We need only recognize the panic that ensues when economic growth merely slows down to realize how foundational a belief in unlimited growth is to the dominant culture of Integrated World Capitalism. Even at moments of apparent crisis, no pundit ever questions the assumption of growth, but rather espouses all sorts of ideas about how we can revive spending. A belief in the benefits of unlimited growth is part of "the natural world to which my mind is connected," just like "the green grass and trees, the sighing of the breeze, the rising of the sun…"

Gielen has signaled his intent to undermine casual viewing of his landscapes through a number of techniques: 1) calling his landscapes Ciphers (i.e., a secret writing, a code, something that needs to be *de*-ciphered); 2) the essentially forensic manner of image composition and sequencing, where the same scene is considered from a number of angles and where patterns are emphasized; and 3) the insertion of curated specialist voices from the fields of urban planning, architecture, and art into the content of the book.

At first glance, Gielen's landscapes appear to us as cancer cells seen under a microscope, as sci-fi conjurations, as microchips, but not as the banal suburban developments they actually are. It is the same conceit as *The Twilight Zone* or the stories of Kafka. This insertion of abnormality becomes a means to provide an insinuating critique on social issues.

In part, the weirdifaction of such normal landscapes can be attributed simply to the choice of shooting these developments from the air. Despite their increasing prevalence, aerial images are not much like our direct perception of the world—that type of passive and always churning vision that happens when we merely open our eyes. As Kim Sichel has

pointed out in her catalog essay for an exhibition of contemporary aerial photography, there is "no horizon, no vanishing point, no human scale and few nuances of light and shadow." Furthermore, "where we are accustomed to standing in one place and seeing life move in front of us, aerial views are uncannily still."[9]

Gielen capitalizes upon and extends the fundamental estrangement that comes from aerial views. In the first place, he frames his images to present us with what appear to be discrete shapes or entities, playing on our innate reflex to perceive pattern. Then, he meditatively moves around these discrete shapes mimicking in his image selection the manner of analysis or consideration. Such a manner indicates the study of something that is unknown or unclear but of significant interest (i.e., a Cipher). Yet, Gielen does not immediately suggest a given taxonomy or interpretative structure for these Ciphers in the manner of Alex MacLean. Nor does Gielen adorn his images with extravagant technique, in the manner of Emmet Gowin or Mario Giacomelli—a type of gesture that can cut short the experience of estrangement by putting the image squarely within the conventions of

modernist art. Moreover, he does not seek to render analysis feeble by the raw imposition of "imperial beauty" in the manner of David Maisel.

Gielen's images invite cool analysis and evidentiary consideration, but at the same time provide no basis for such an analysis. This leads to a little shock or panic that is the primary emotional content of the photographs. Such a response is available even to the most casual viewer. Anybody can see that these are very ordinary housing developments, but their aesthetic treatment as unfathomable growths to be considered from every possible angle in a vain attempt to comprehend them makes them appear as malignant, threatening, uncanny (in the precise Freudian sense of both familiar and unfamiliar, hidden and revealed, known and denied).

TREMORS AND CULTURAL FOUNDATIONS

We must concede that this sort of tremor caused by an evocation of the Uncanny or Sublime (and not even direct contact) can shake belief a little but hardly crack its foundation. That is about the best a photograph can hope for, at least a pensive photograph. A lot of misconceptions about the nature of activist art stem from attempts to attribute either too much or too little efficacy to it. It does what it does. Enough tremors and those foundations *will* actually crack. Or else that isolated tremor recollected at the time of voting or of consuming may influence behavior in a way as palpable as a direct experience. This is not trauma exactly, but more like an intimation of trauma. Yet the effect is cumulative. A photograph's impact should not be judged in isolation but as part of a larger cultural effort of which it is a part. Art makes a space for belief; and belief makes a space for change.

THE MICROSCOPE

Leaving aside their pensive qualities, Gielens's photographs offer a number of concrete insights with respect to ecology and unsustainable growth, which complement the action they perform upon belief in the possibility of catastrophe. The most salient piece of information, which is available in every one of the featured images in this book, is the artificiality of the quasi-urban forms and the lack of systemic consideration for the surrounding environment. The developments strike us first and foremost as impositions, as inva-

sions. They are manifestly unecological in the sense that an ecology is defined by relationships between entities within a given system and thrives on diversity. These landscapes are monocultural in every sense.

These developments seem like impositions because the edges are so hard. There is such an absolute boundary between these forms and the surrounding land (if such land can even be seen). This is particularly striking in the series *UNTITLED XII/IV/XII* from Nevada, where the microchip-shaped development has been carved into the desert landscape and seemingly walled off from it. What accommodation has there been made in this development for the power of the sun (such as solar panels or even passive solar constructions), which is surely the dominant feature of that ecosystem? What space has been given over to harvest scant water resources? Even where so-called natural features such as water or green space have been factored into the design, as in the *UNTITLED X/XII/XI* series from Arizona, there is no effort to integrate those features into the domestic areas, but rather these features too are pushed into symmetrical "design" forms that are purely decorative.

The unsustainable nature of the developments can be seen in the contrast between Gielen's images of the Florida developments (*Sterling Ridge* and *Sky Isle*) and his images of the nearby Everglades. The Everglades refers to a vast system of wetlands that at one time encompassed nearly all of Florida, but which has since been canalized, drained, and diminished to the point of possible collapse in order to make way for housing developments and agriculture. Gielen published his images of the Everglades with *The New York Times* in a written piece and slideshow co-authored with Tim Doody.

Here is Doody describing the images:

...the effects of sprawl were written all over the terrain: marshes reduced to a fraction of their former size; shrinking river-delta channels, known as sloughs; and the infamous "white zone," a stagnant, hyper-salinated coastal area that has crept inland from the Atlantic since 1940. All of these are indicators of a dying ecosystem, driven to collapse by overdevelopment.[10]

Gielen's photographs are explicitly marshaled here for the purpose of illustrating a very clear point: the Everglades are endangered due to poor land management decisions, but have a chance to rebound with new legislation and newfound

concern for their stewardship on both the state and federal level.

One of the experts brought in to interpret the images for this piece, former United States Secretary of the Interior Bruce Babbit, declares, "The land is crying out for water." Gielen's photographs of the Everglades gain contrast especially when put side-by-side against such glib uses of water as a landscape feature in the so-called Sky Isle development, which is actually in Naples, Florida, a city carved out of the wilderness in the late nineteenth century and currently a jumping-off point for tourism in what is left of the Everglades.

Another piece of concrete information that we can glean from the images, particularly those in the *Outer Houston* series, is the size of the houses. According to U.S. Census Bureau data, the average size of houses in the United States has more than doubled in the last seventy years, growing from 1,100 square feet in the 1940s to a new record high of 2,306 square feet in 2012. The amount of space on the planet is finite. So rising population coupled with rising demands for per capita land use is obviously not a sustainable formula. Various entities have speculated on "how many planets" the size of the earth we would need if all people of the world lived like North Americans. A recent calculation put that number at 4.1.[11] While such exact calculations are obviously fraught with assumptions and are estimates at best, the underlying point is valid. We just can't do it. So something has to give.

DEVELOPING WORLD

The unsustainability of current growth trajectories becomes particularly obvious when we consider China, India, and the developing world. Are we supposed to tell the people of the developing world that they are not entitled to the comforts and lifestyle we have been enjoying? That does not seem just, but what are our alternatives? China is a particularly vexing case. Everything about the scale of China is terrifying, like a huge wave about to break upon the shore. According to a 2007 study, it builds two coal plants a week (a week!) and brings online an electricity capacity comparable to the entire UK power grid each year.[12] China already has five cities larger than New York (several of which you have probably never heard of) and by 2025 it "will have 221 cities with one mil-

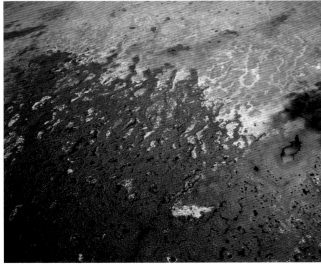

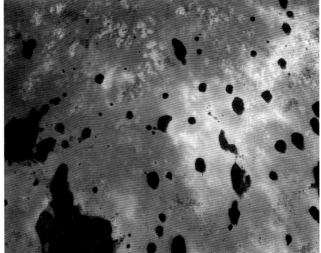

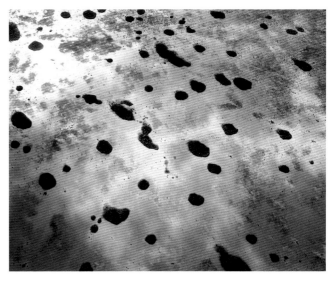

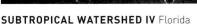

SUBTROPICAL WATERSHED IV Florida

SUBTROPICAL WATERSHED II / III Florida

lion–plus inhabitants—compared with 35 cities of this size in Europe today."[13] The largest building in the world, which is located in Chengdu, was recently opened. This building, called The New Century Global Center, is four times the size of the Vatican and "features an artificial sun that provides light and heat throughout the day, while an LED screen 164 yards in length provides an artificial horizon," according to one article on the building.[14]

Yet of all the staggering statistics with respect to China the most relevant to this book is the jaw-dropping plan of the Chinese government to relocate by fiat no less than 250 million people from rural to urban areas (and areas often explicitly developed for this relocation process). They plan to accomplish this in twelve to fifteen years. Think about this for a moment: 250 million people is equal to the entire population of the United States in 1990 (the population of the United States now is around 313 million). Can you imagine the forced relocation of an entire country? Furthermore, the matter is not as simple as a physical relocation. What is intended is no less than an entire lifestyle makeover. The reason China is relocating people is "mainly to find a new source of growth for a slowing economy that depends increasingly on a consuming class of city dwellers," according to a recent report in *The New Times*.[15] To support its continued growth, which is the de facto and unquestioned aim of nearly all world governments today, China needs more people—a lot more people—buying televisions and cars and

computers and sneakers and baseball caps. No anecdote more clearly exposes the need to overcome our faith in the everlasting benefits of continued growth. There is absolutely no way to reduce carbon emissions and thus to mitigate risk of complete catastrophe in such a political climate.

KONGJIAN YU AND THE ARTS OF SURVIVAL

We set out to answer a question that Gielen specifically posed to us: what good are these photographs in the face of climate change? But to put a finer point on it we might ask: what good are these photographs in the face of the central planning authority of the Chinese government, or the broken, polarized legislative system of the United States?

We have written at length about the potential cultural impact of projects like this book, and no matter how difficult it is to see in the moment, there is no question that a government's power, even in China, derives from its people. Changing social realities, changing social concerns will ultimately change governments, either slowly or, if that change meets resistance, all at once and with violence. China, for example, is creating an extremely combustible situation within its borders through the forced migrations of its people, a prospect that may seem good in the short-term because of stipends offered by the government, but what happens when those stipends run out? Likewise the United States is creating a combustible situation by becoming increasingly myopic in its governance and by becoming increasingly focused on the

short-term profits of corporations instead of the long-term prosperity of its people. Gielen's images (and literally thousands of like-minded projects) can help bring about a tipping point in consciousness.

In the meantime, Gielen's images, because they are of actual places at an actual point in time, provide useful visual information immediately. The type of development seen in the images can be read as emblematic of archaic and dangerous land-use management and can provide concrete examples of what to avoid. These stagnant, resource-draining landscapes are an example that can be heeded by any government, any planning authority.

If such a prospect seems far-fetched, consider the work of Kongjian Yu. Yu is an influential thinker, planner, and landscape architect working within China. He is the founder and Dean of the School of Landscape Architecture at Peking University and the founder and head of Turenscape—a 500-person design firm that implements multiple projects each year, almost entirely within China itself. In a recent interview, Yu defined what he sees as the future of landscape architecture and planning as follows:

We've misunderstood what it means to be developed. We need to develop a new system, a new vernacular to express the changing relationship between land and people.... It should address the issue of survival, not pleasure making, or ornament. It should be for survival, because we are now, as human beings, at the edge of survival.[16]

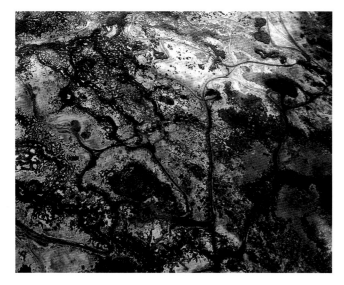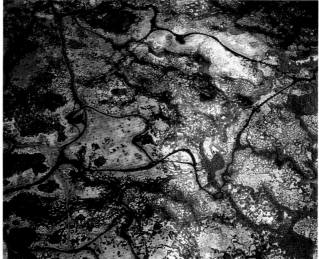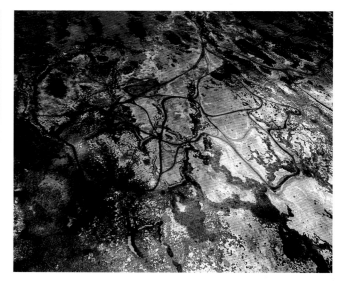

DROUGHT II/IV/I Florida

For Yu, a survival-focused planning and development practice is fundamentally based on "ecological awareness and environmental ethics."[17] By which he means: "like a successful organism, a place will sustain its identity when its design is adaptive—when it responds elegantly and efficiently to its environmental setting so that new uses can endure."[18] Notably, Yu begins his analysis of a given project with aerial views and then zooms in. He is looking for what he calls "ecological infrastructure that will guide urban development." Yu defines ecological infrastructure as "the structural landscape network composed of critical landscape elements and spatial patterns."[19] In other words, everything that was ignored in the developments that Gielen highlights in this book. Indeed, Yu's expressed point of departure is the realization that China cannot urbanize to the extremes it is currently planning on, if it employs the very type of lifestyle and development ethos exhibited in Gielen's landscapes.

Because Gielen works with photography's intrinsic indexicality rather than try to outwit it, as many contemporary art photographers seem intent to do, his images can function as raw data with which urban planners like Yu can compare and contrast. In this way, his photography not only works on belief in the manner expressed above (jarring us loose from an unquestioned faith in unlimited growth), but also on knowledge, by giving us concrete information about real places in real time. Gielen's images exert both bottom-up and top-down pressure on a changing culture. Each of the

other essays in this book, but most particularly the work of Galina Tachieva, show what can be done with a specific analysis of Gielen's forms.

Of course, most readers of this book will not be professionals of the sort to make elaborate use of Gielen's images. So what will you do with the information he provides? Only you know and you may not know yet. The ultimate value of the images depends entirely on the viewer living up to her end of the civic bargain.

Susannah Sayler and Edward Morris

[1] See: William R. L. Anderegg, James W. Prall, Jacob Harold, and Stephen H. Schneider, 2010. "Expert credibility in climate change." *Proc. Natl. Acad. Sci. U.S.A.* 107 (27): 12107–9; J. Cook, D. Nuccitelli, S. A. Green, M. Richardson, B. Winkler, R. Painting, R. Way, P. Jacobs, A. Skuc, 2013. "Quantifying the consensus on anthropogenic global warming in the scientific literature." *Environ. Res. Lett.* 8 (2): 024024; Peter T. Doran and Maggie Kendall Zimmerman, January 20, 2009. "Examining the Scientific Consensus on Climate Change". EOS 90 (3): 22–23; and Naomi Oreskes, 2007. "The Scientific Consensus on Climate Change: How Do We Know We're Not Wrong?" in Joseph F. C. DiMento and Pamela M. Doughman, *Climate Change: What It Means for Us, Our Children, and Our Grandchildren*. MIT Press. pp. 65–66.

[2] From a book proposal for: Thomas Nocke and Birgit Schneider (eds.), *Image Politics of Climate* (working title), Bielefeld: transcript, 2013.

[3] Michel De Certeau, *The Practice of Everyday Life*, trans. Steven Rendall, Berkeley: University of California Press, 1984, 177–189.

[4] Slajov Zizek, *Living in the End Times*, London: Verso, 2011, 445–446.

[5] The term negative capability was coined by John Keats who defined it as "when a man is capable of being in uncertainties, mysteries, doubts, without any irritable reaching after fact and reason." The term was later appropriated by social theorist Roberto Unger, who gave the following definition: "denial of whatever in our contexts delivers us over to a fixed scheme of division and hierarchy and to an enforced choice between routine and rebellion." Roberto Unger, *False Necessity: Anti-Necessitarian Social Theory in the Service of Radical Democracy, Revised Edition*, London: Verso, 2004, pp. 279–280, 632.

[6] Laura Kurgan, *Close Up at a Distance: Mapping, Technology & Politics*, Zone Books, 2013, as found in Trevor Paglen's review of the book, "Ways of Seeing," in *Book Forum*, April/May 2013, p. 33.

[7] Ibid.

[8] Erroll Morris, *Believing Is Seeing: Observations on the Mysteries of Photography*. New York: Penguin Press, 2011.

[9] Kim Sichel, To Fly: *Contemporary Aerial Photography*, Boston University Art Gallery, 2007, p.11.

[10] Tim Doody and Christoph Gielen, "They Unpaved Paradise," *The New York Times*, October 7, 2010.

[11] Patrick James, "What would Happen If the Entire World Lived Like Americans?" *Fast Company*, http://www.fastcoexist.com/1680379/what-would-happen-if-the-entire-world-lived-like-americans, August 2012, date accessed: June 22, 2013.

[12] J. Deutch and E. Moniz. *The Future of Coal—Options for a Carbon-Constrained World*. Cambridge: MIT Press, 2007, p. ix. Available at http://web.mit.edu/coal/.

[13] McKinsey Global Institute, "Preparing for China's Urban Billion: Executive Summary," 2009.

[14] Brian Bishop, "World's largest building opens in China complete with artificial sun", *The Verge*, http://www.theverge.com/2013/7/3/4491630/worlds-largest-building-opens-in-china-complete-with-artificial-sun, July 3, 2013.

[15] Ian Johnson, "China's Great Uprooting: Moving 250 Million Into Cities," *The New York Times*, June 15, 2013.

[16] American Society of Landscape Architects, "Interview with Kongjian Yu, Designer of the Red Ribbon, Tang He River Park," http://www.asla.org/contentdetail.aspx?id=20124, accessed July, 2013.

[17] Kongjian Yu, "The Big-Foot Revolution," in Mohsen Mostafavi, with Gareth Doherty, Harvard University Graduate School of Design (eds.), *Ecological Urbanism*, Zurich: Lars Müller Publishers, 2010, p.286.

[18] Kongjian Yu, "The Big Feet Aesthetic and the Art of Survival," *Architectural Design*, 11/2012, Volume 82, Issue 6, pp. 72–77.

[19] Yu, "The Big-Foot Revolution," p.284.

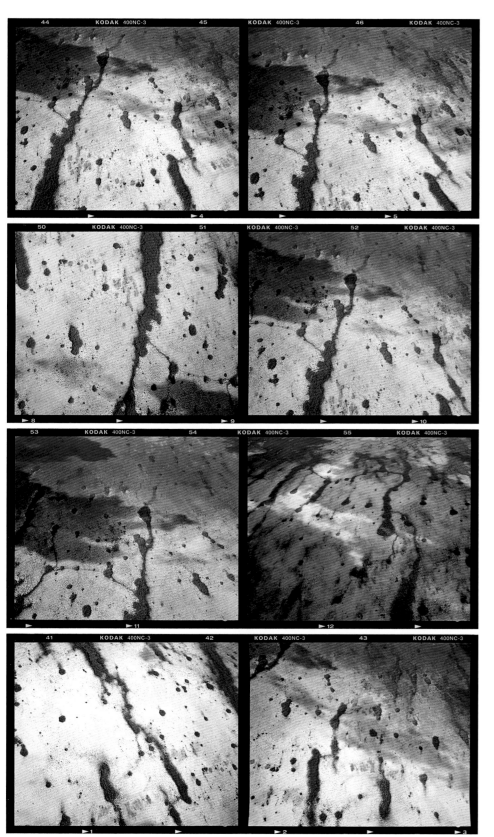

DROUGHT Florida

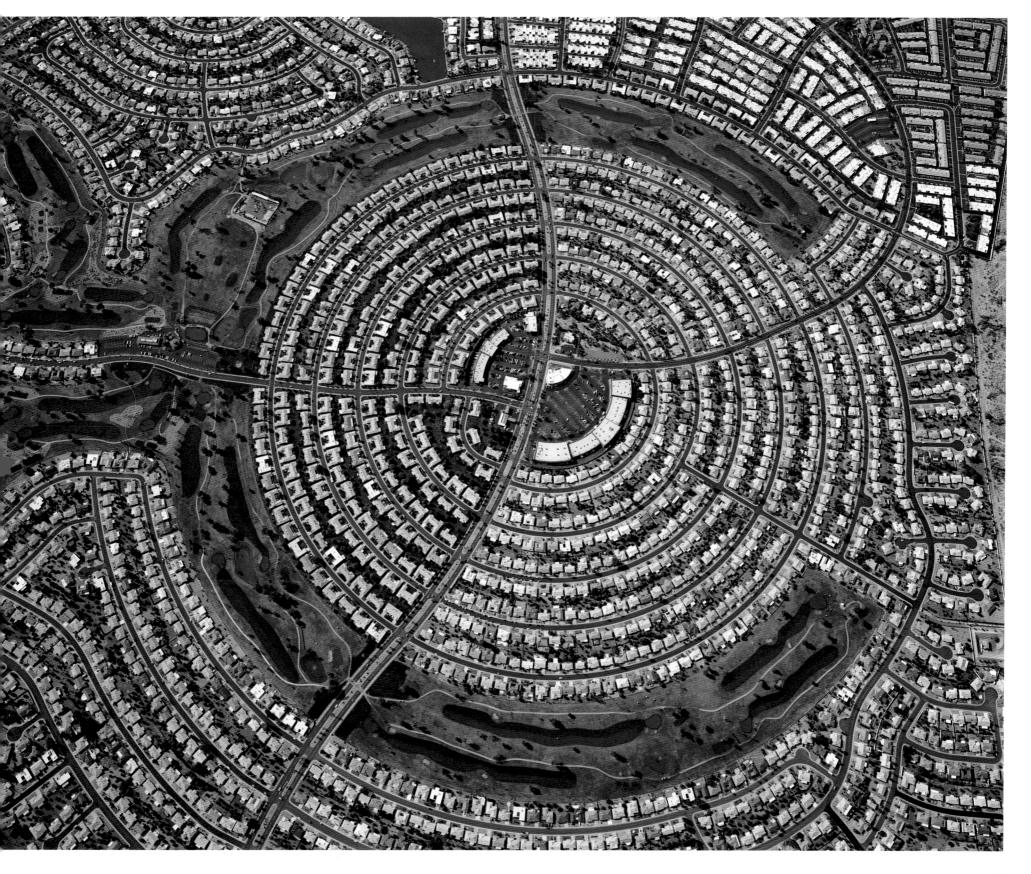

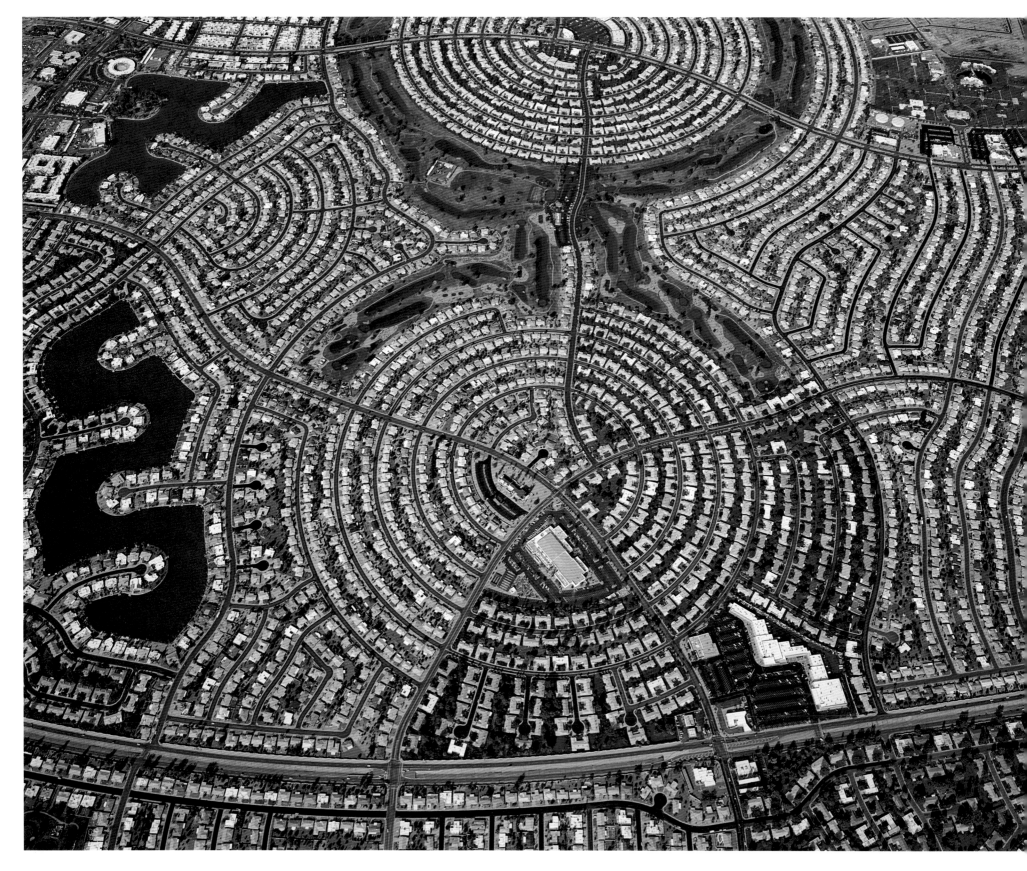

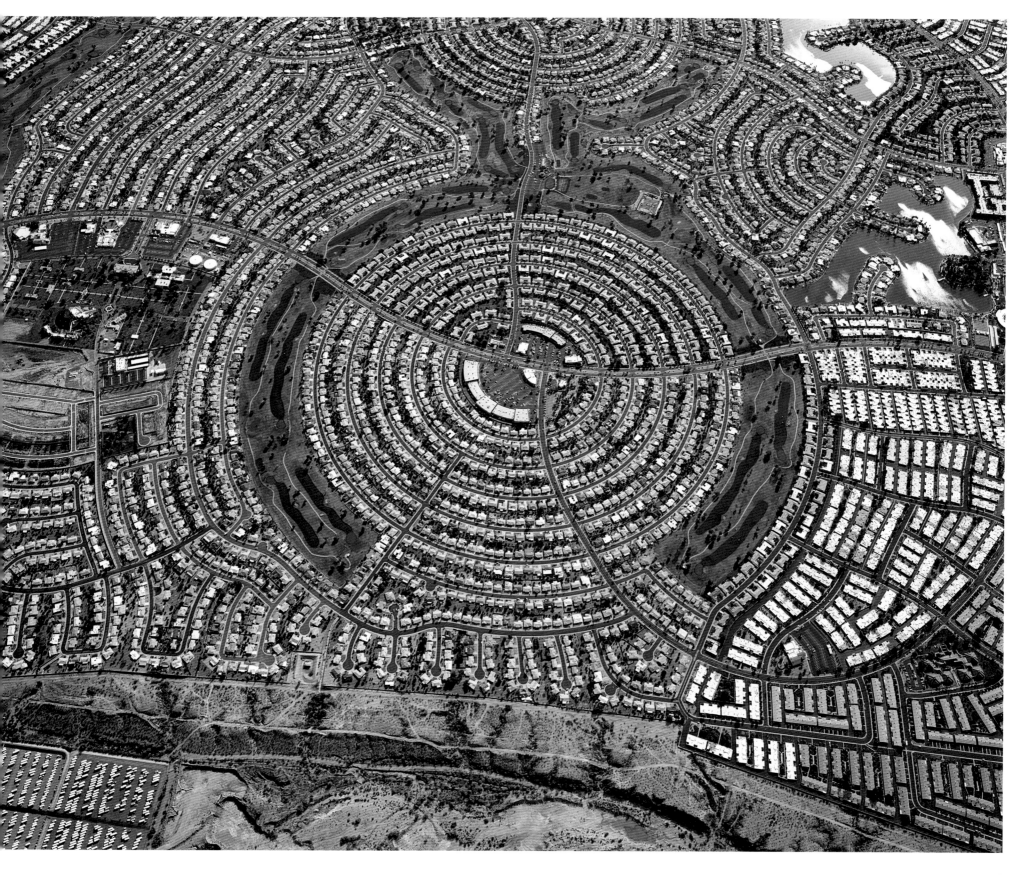

UNTITLED II / X / XI Nevad

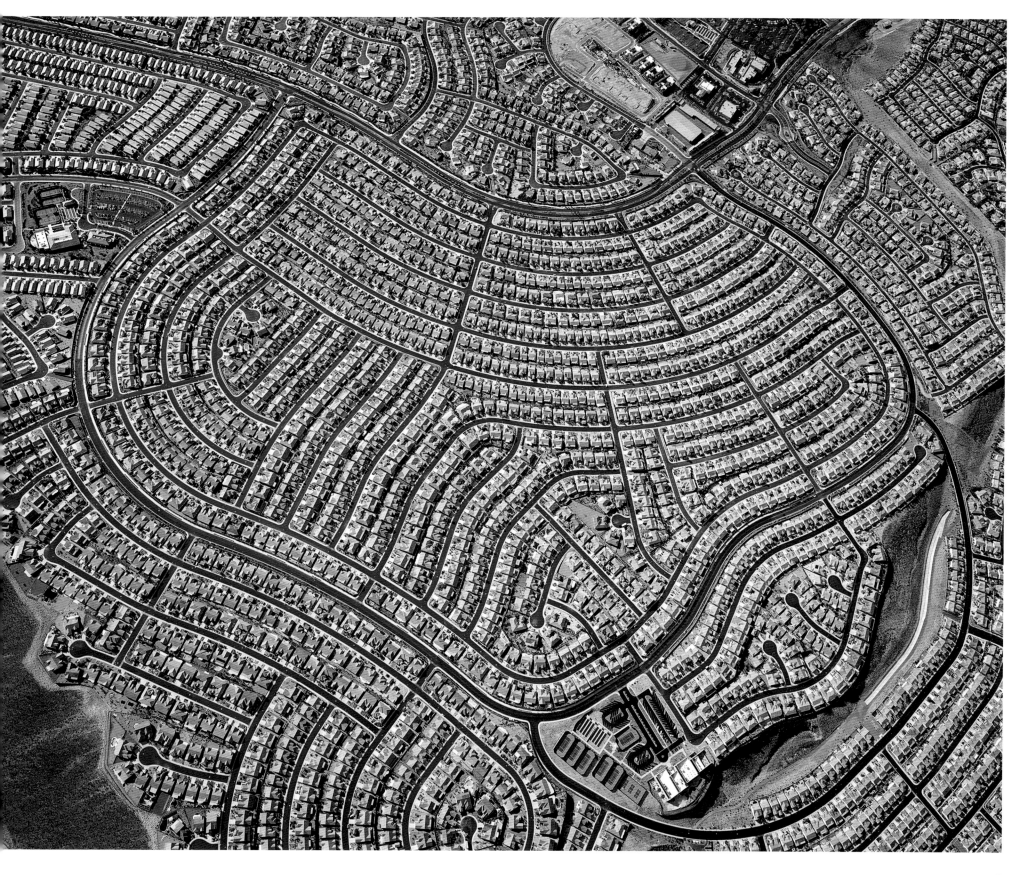

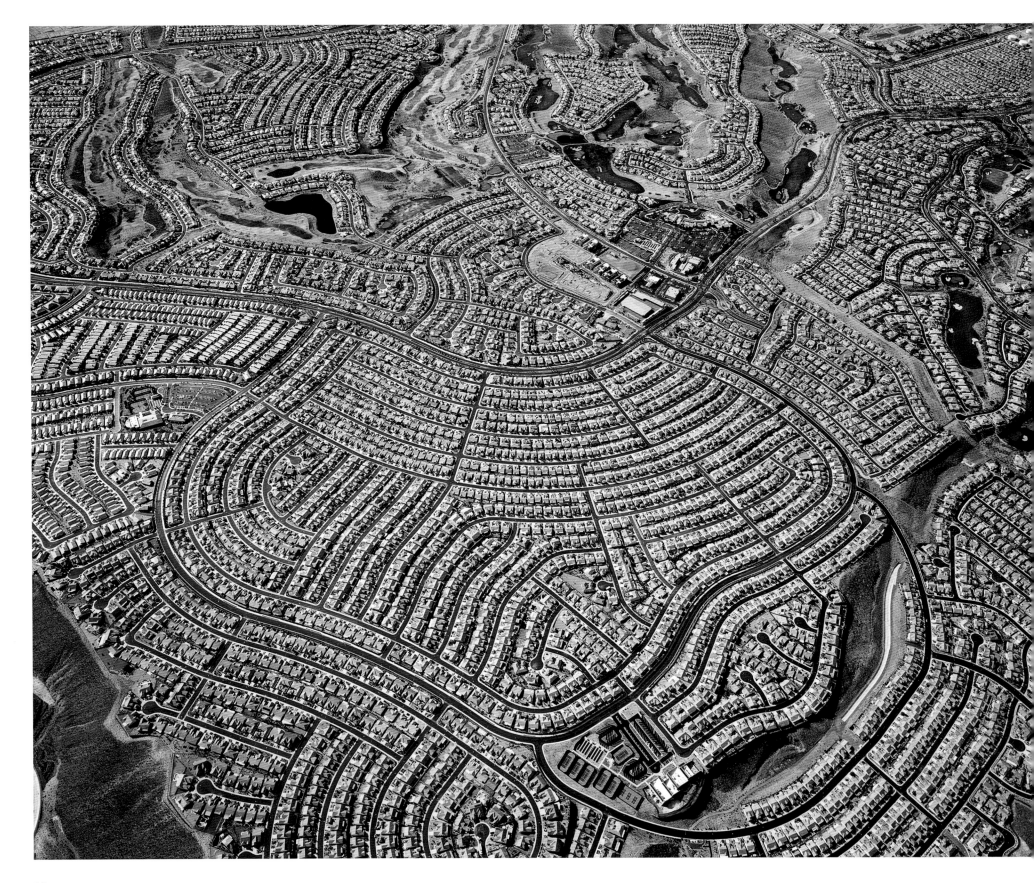

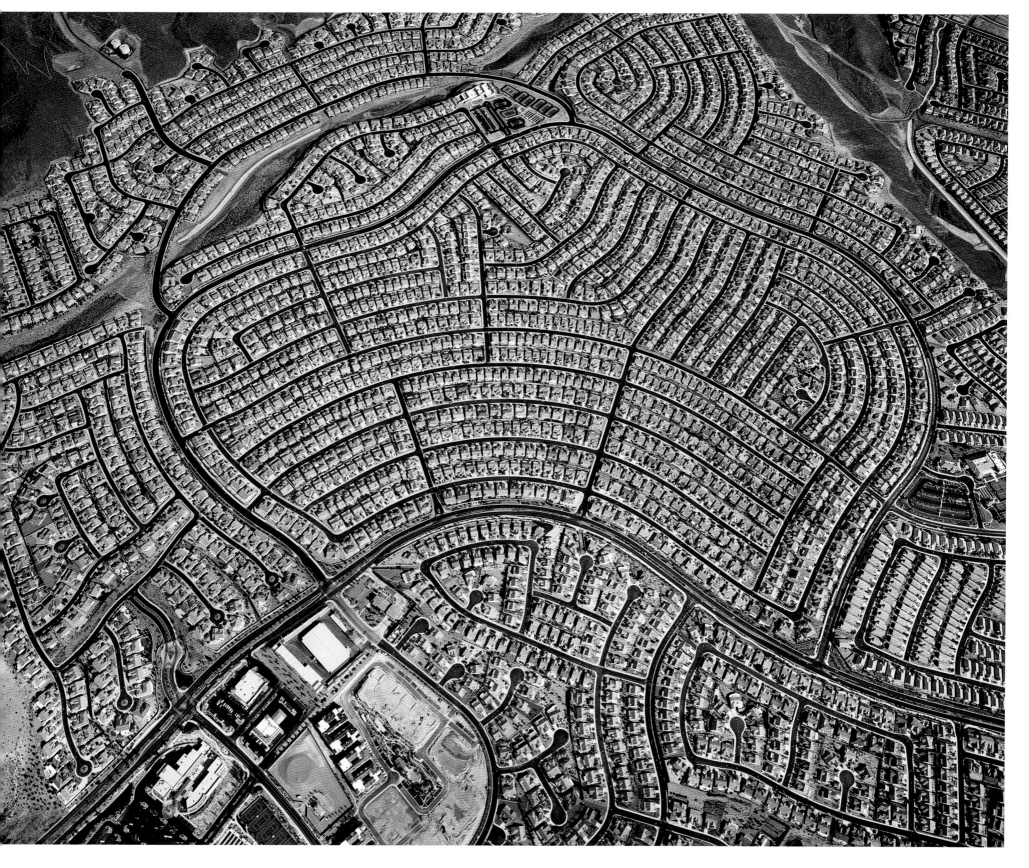

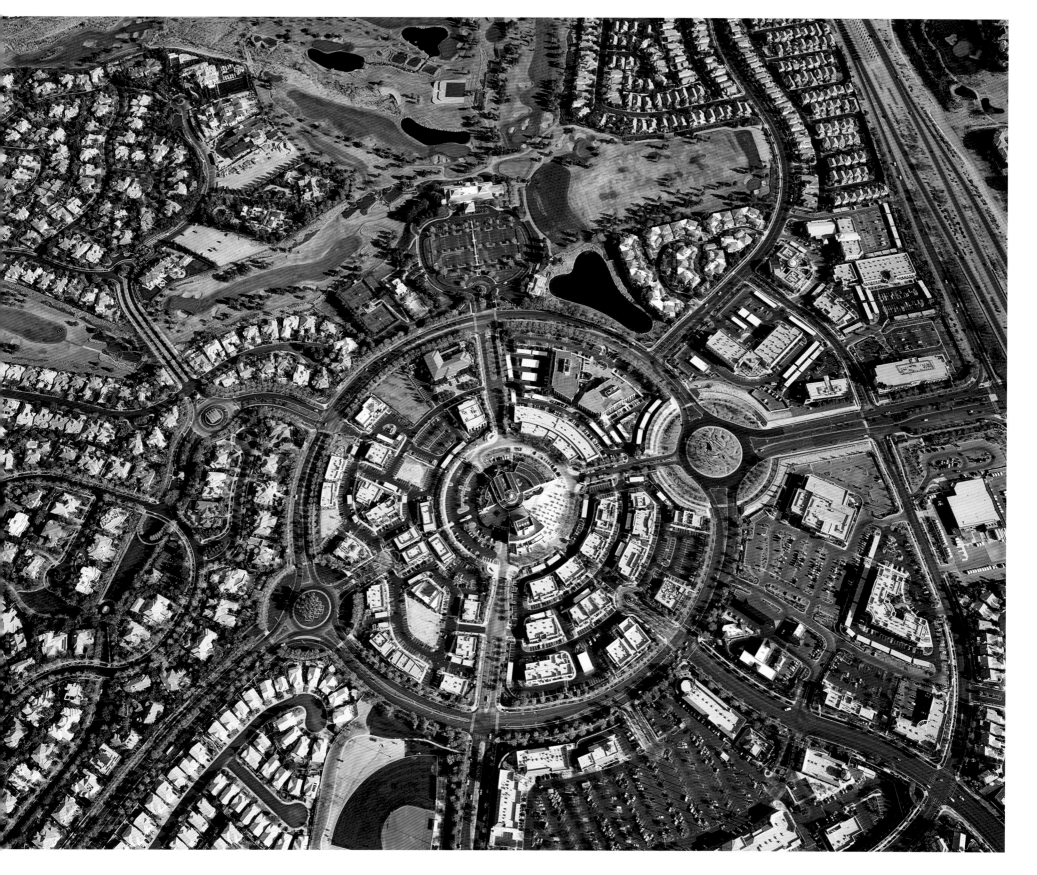

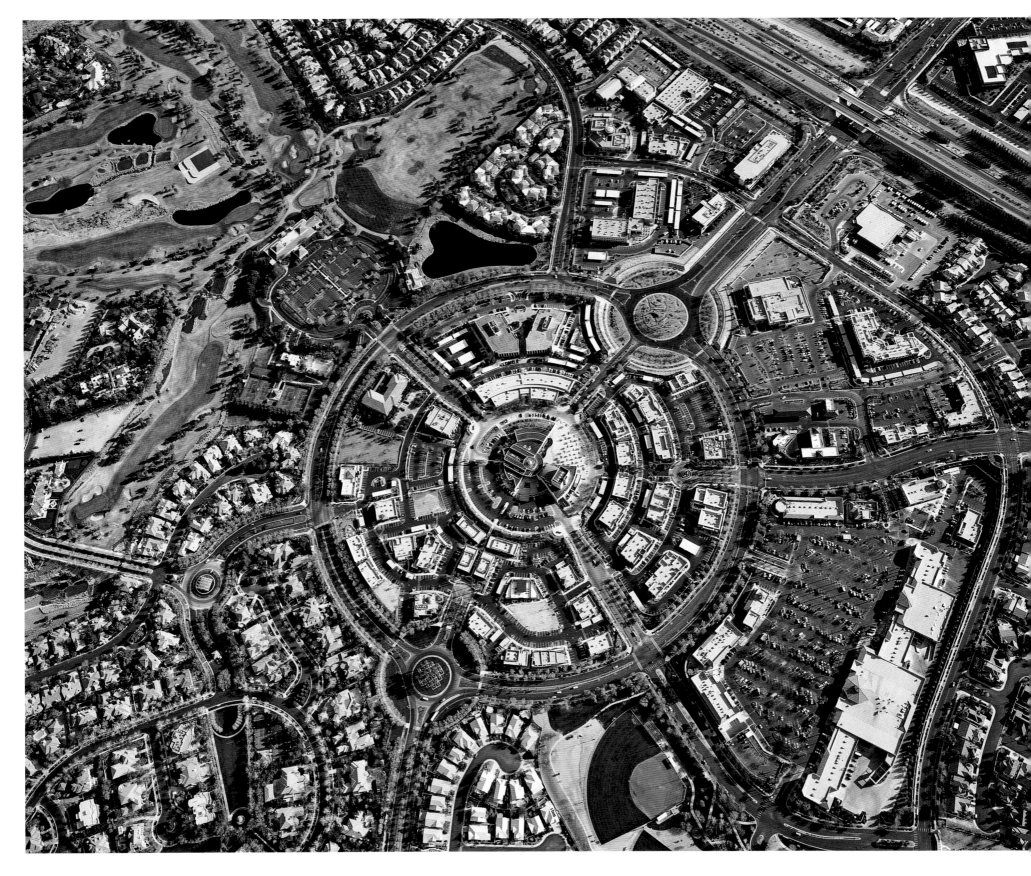

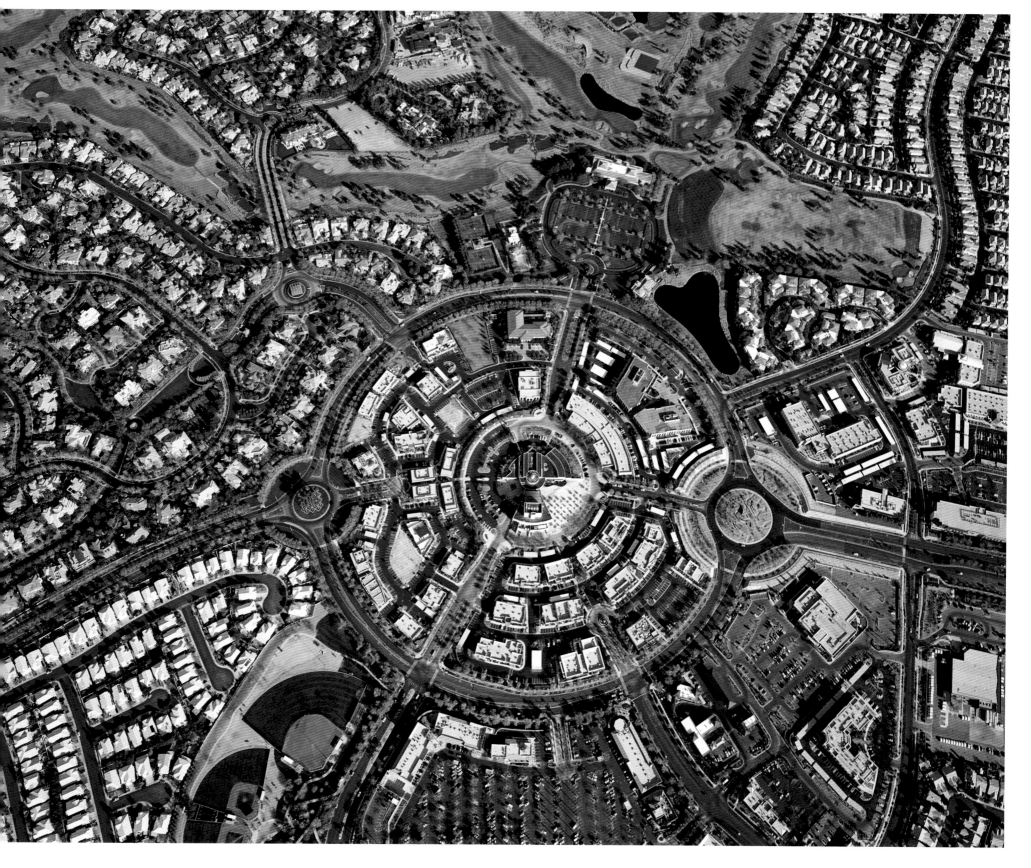

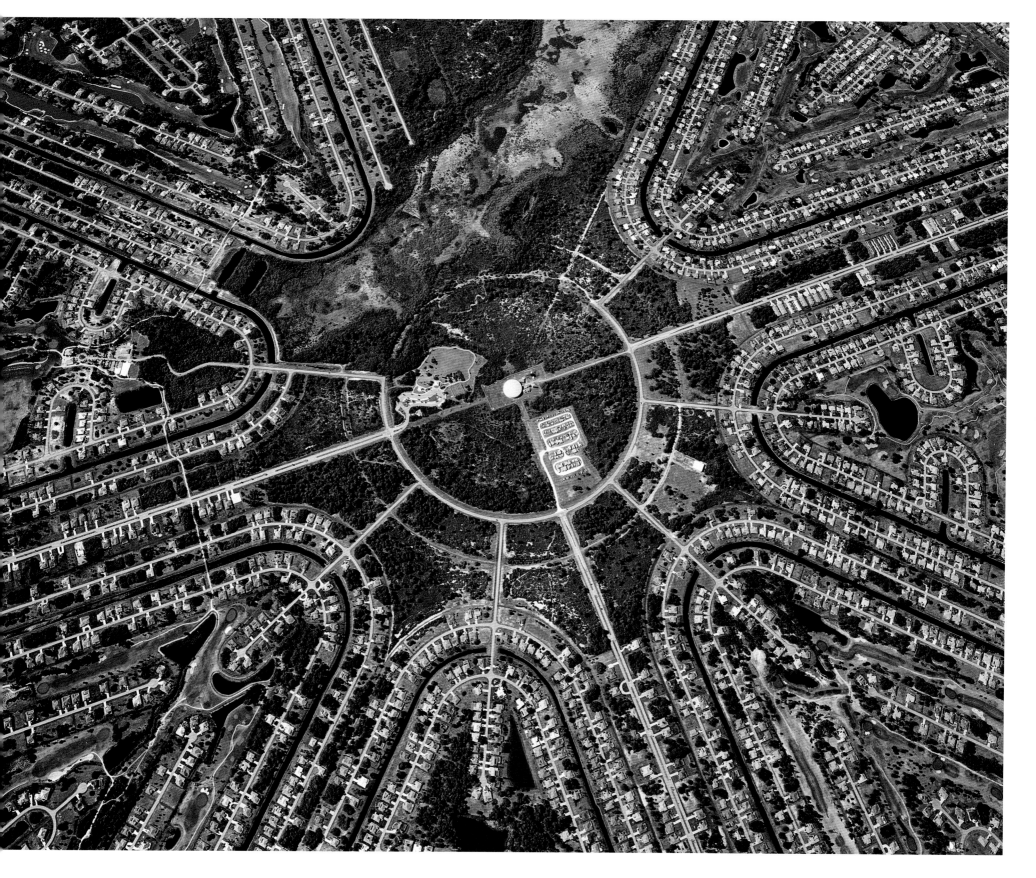

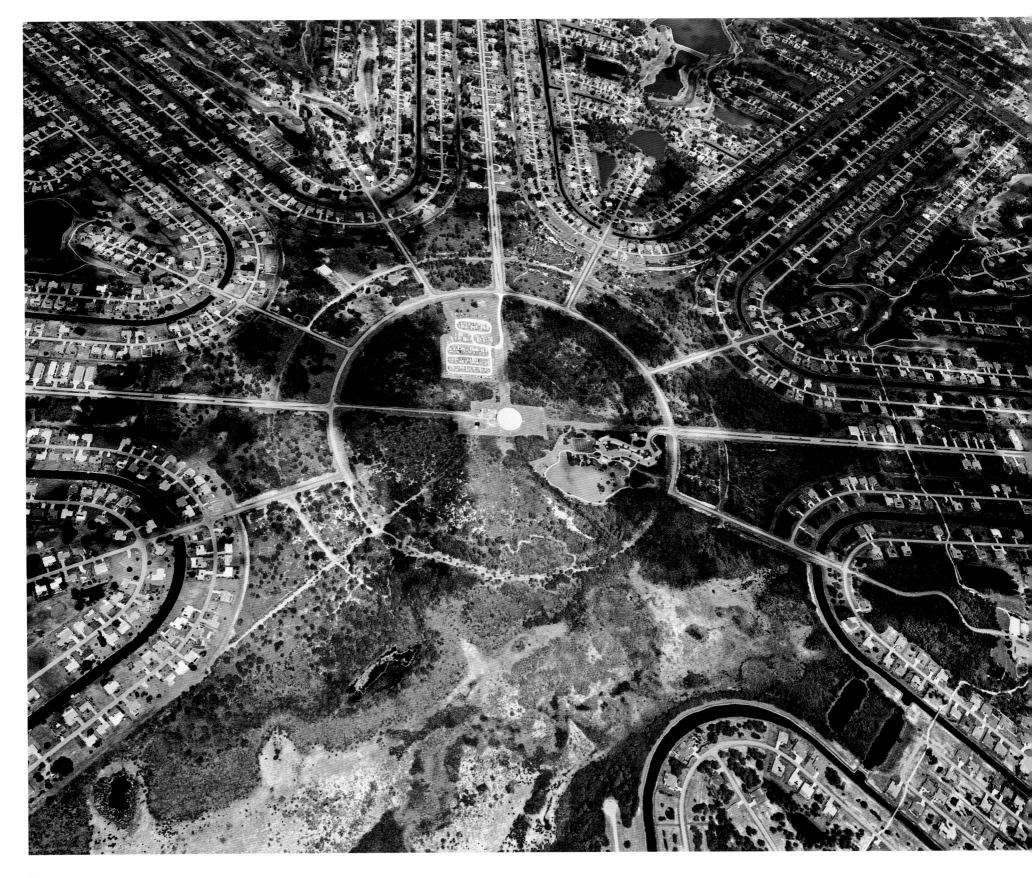

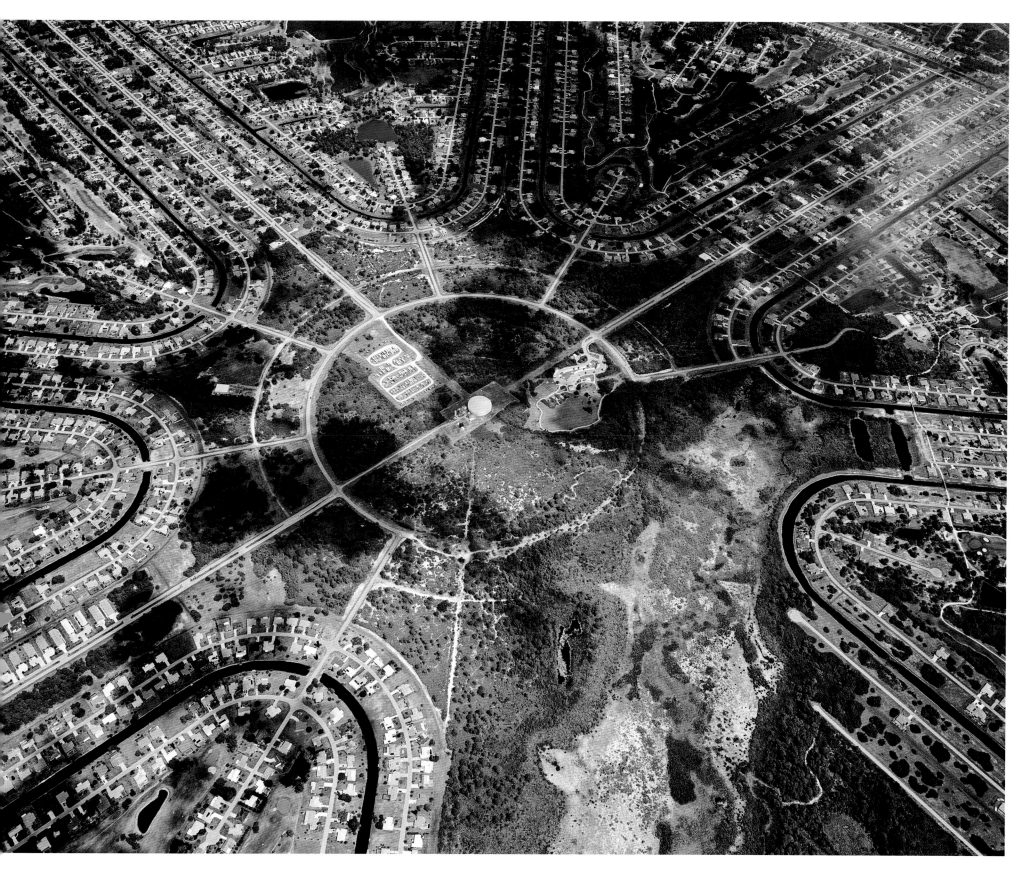

UNTITLED X / XII / XI Arizona

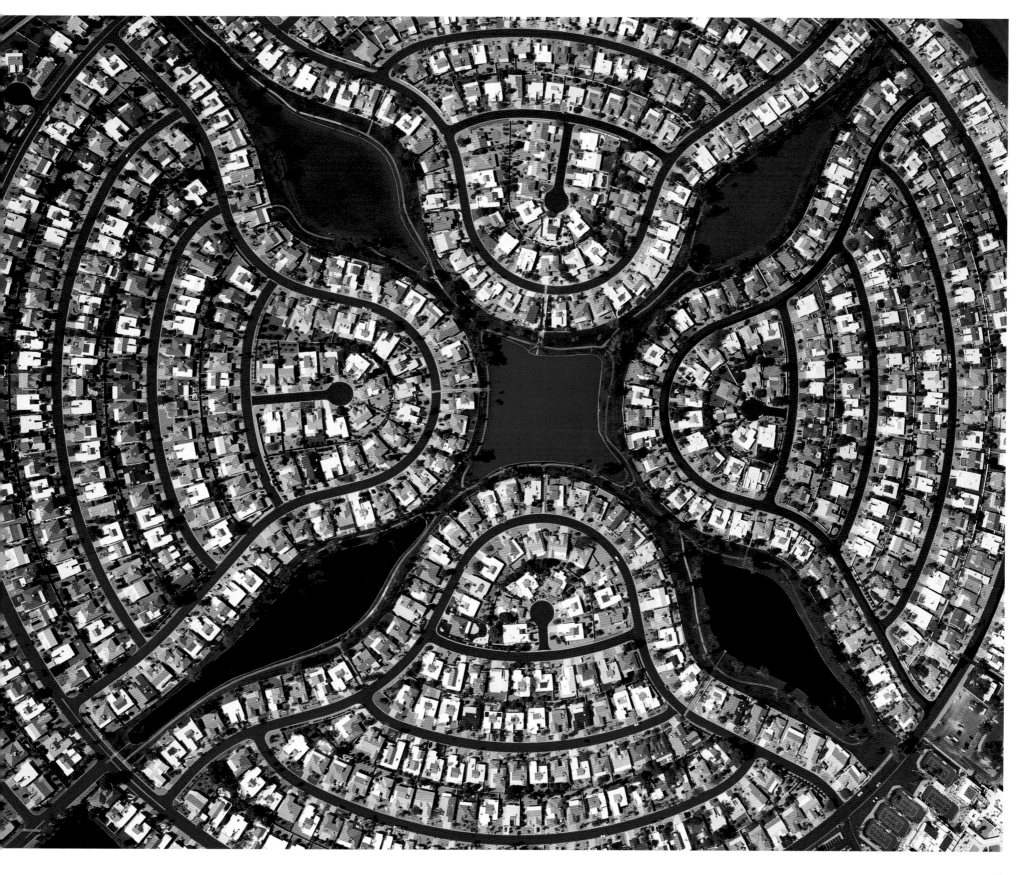

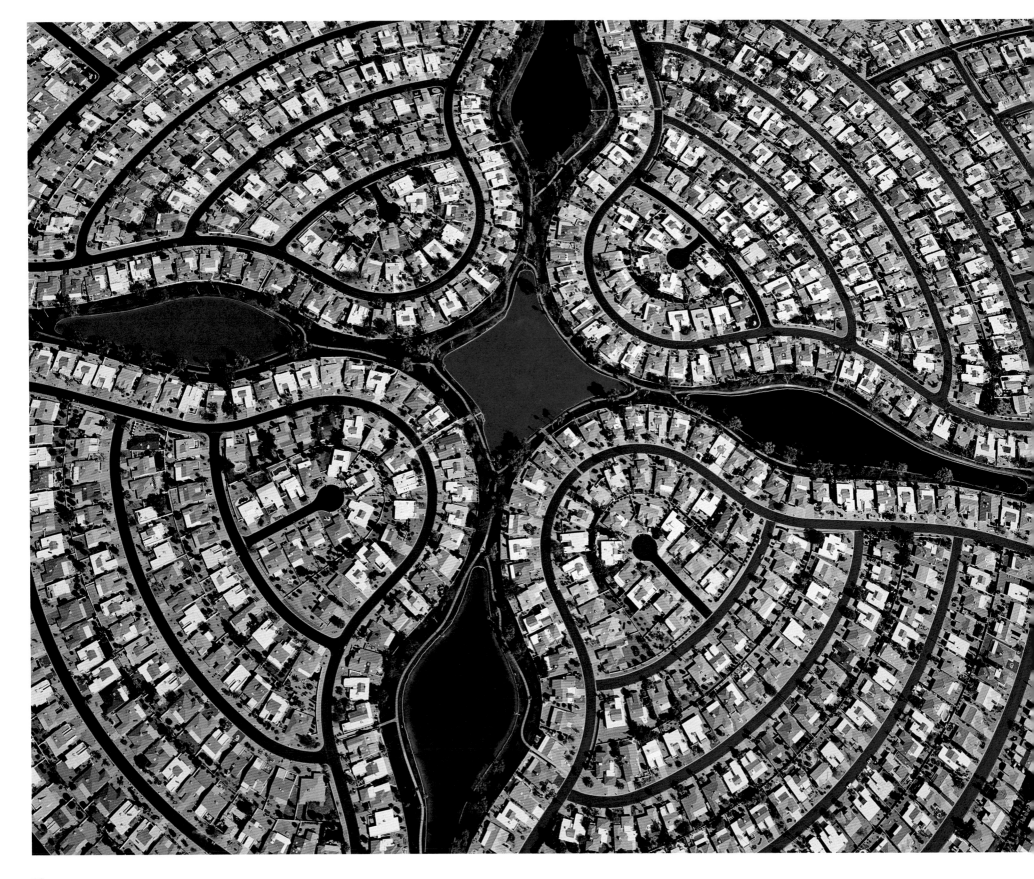

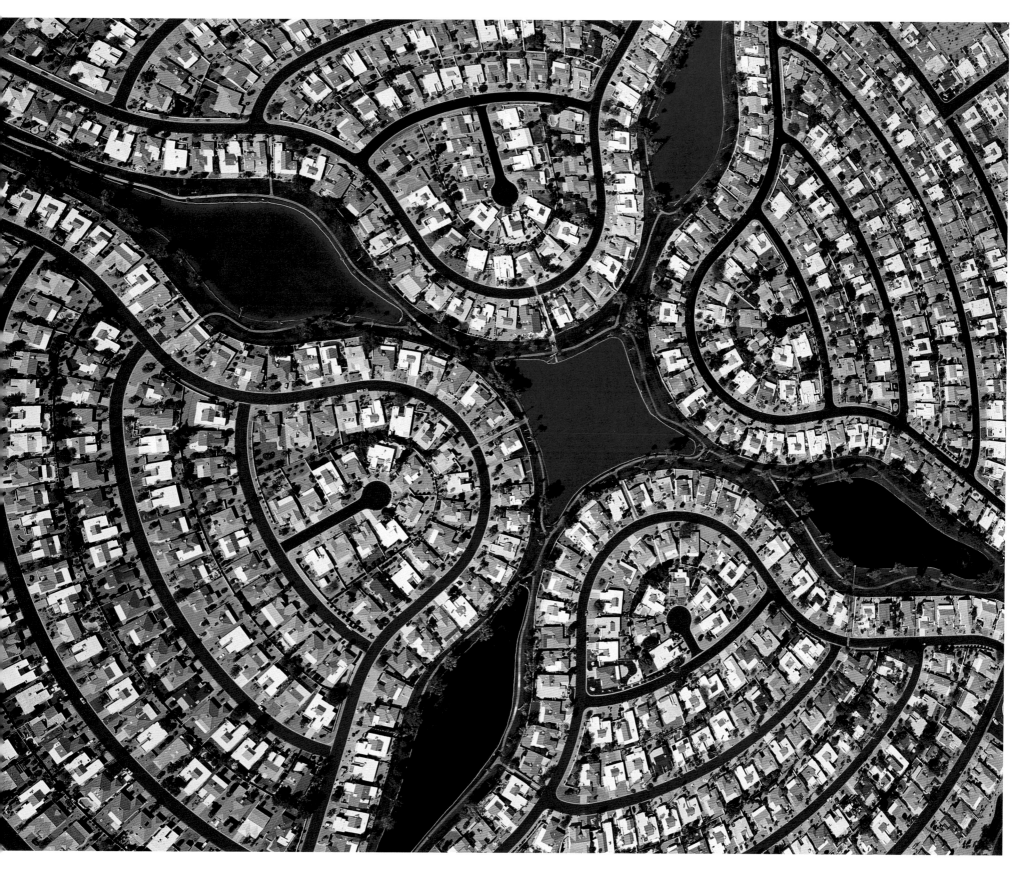

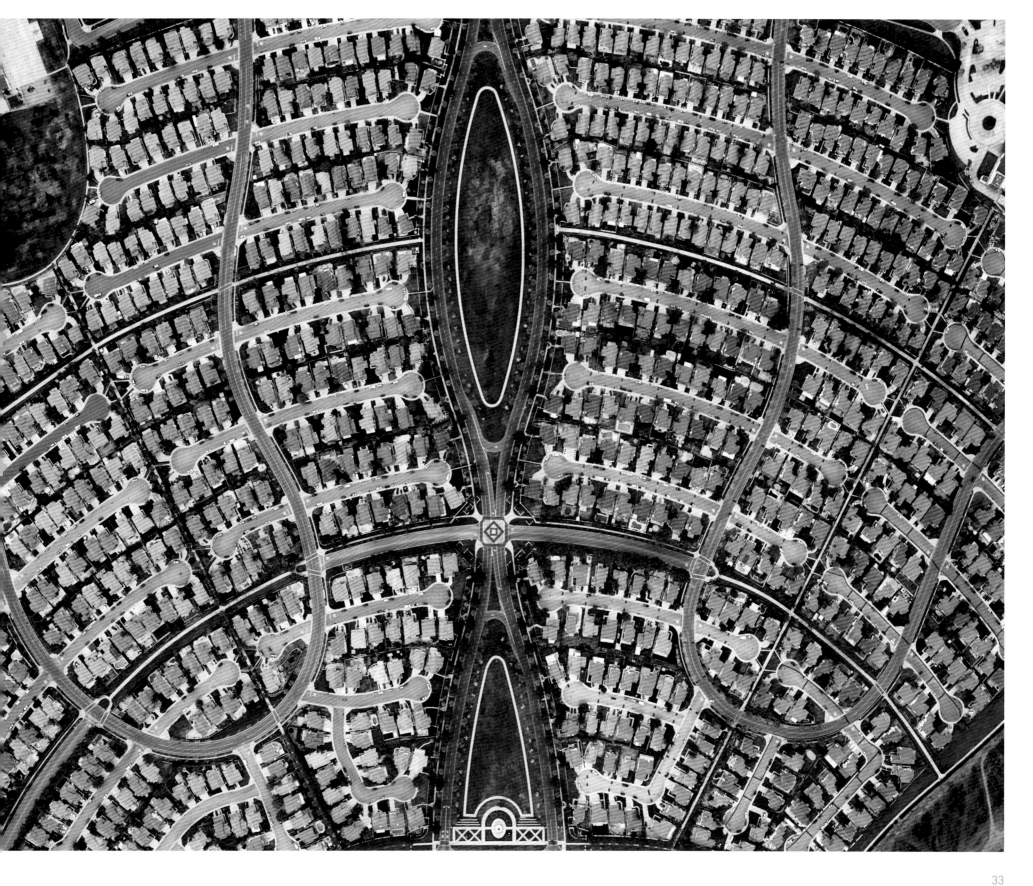

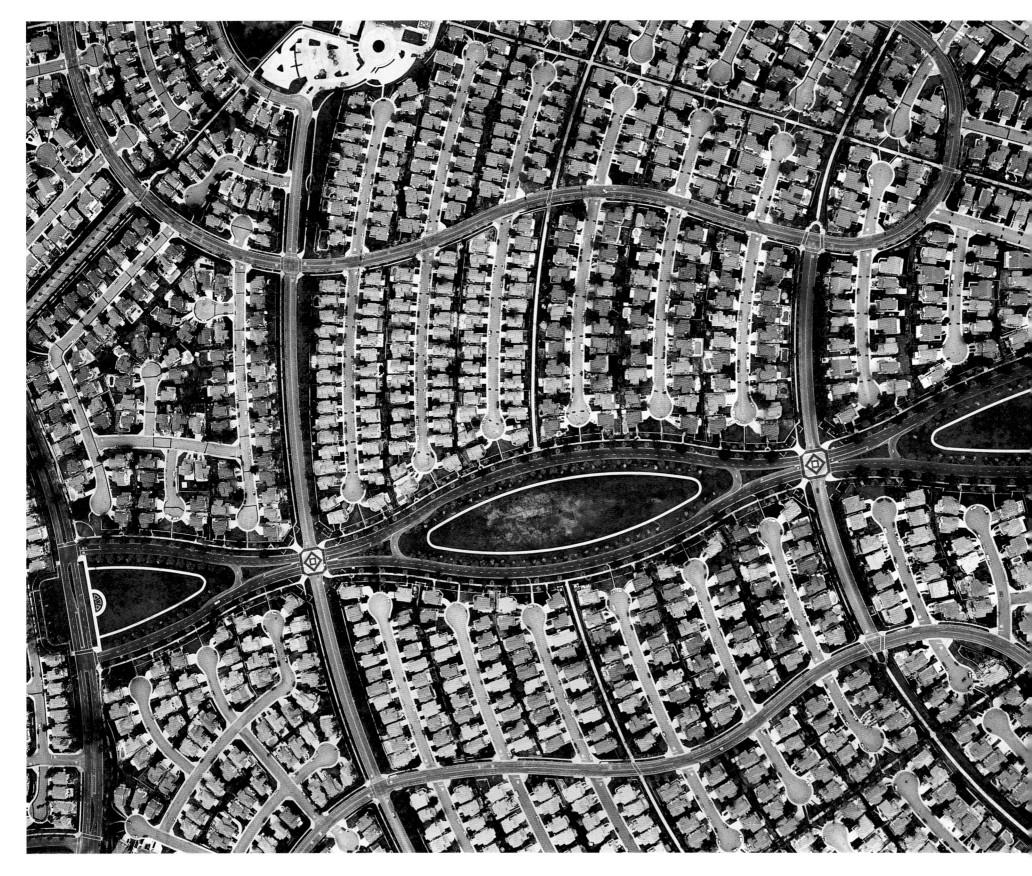

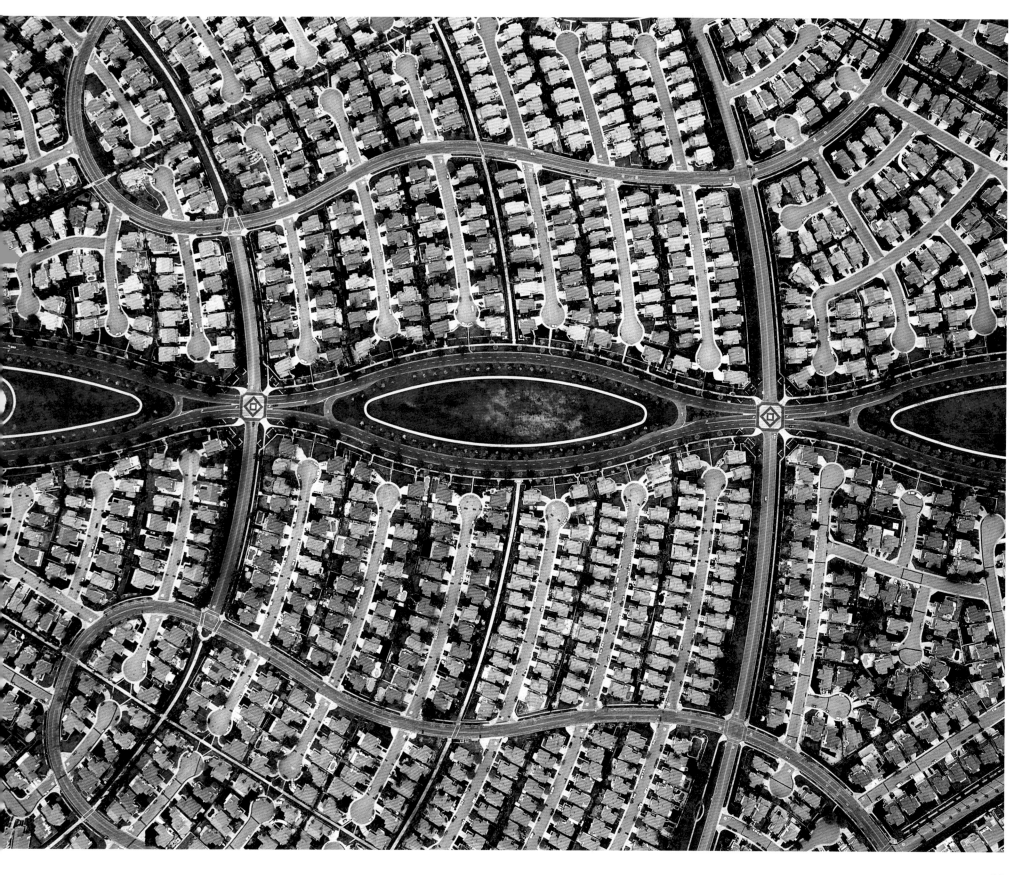

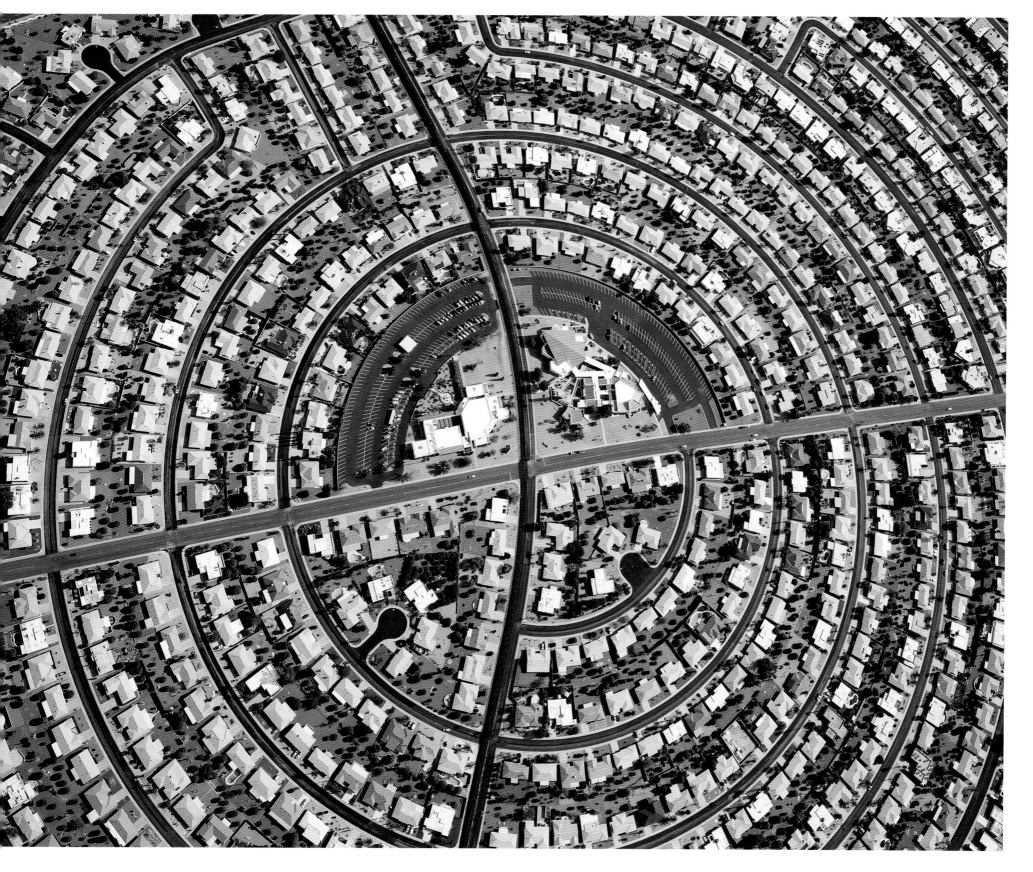

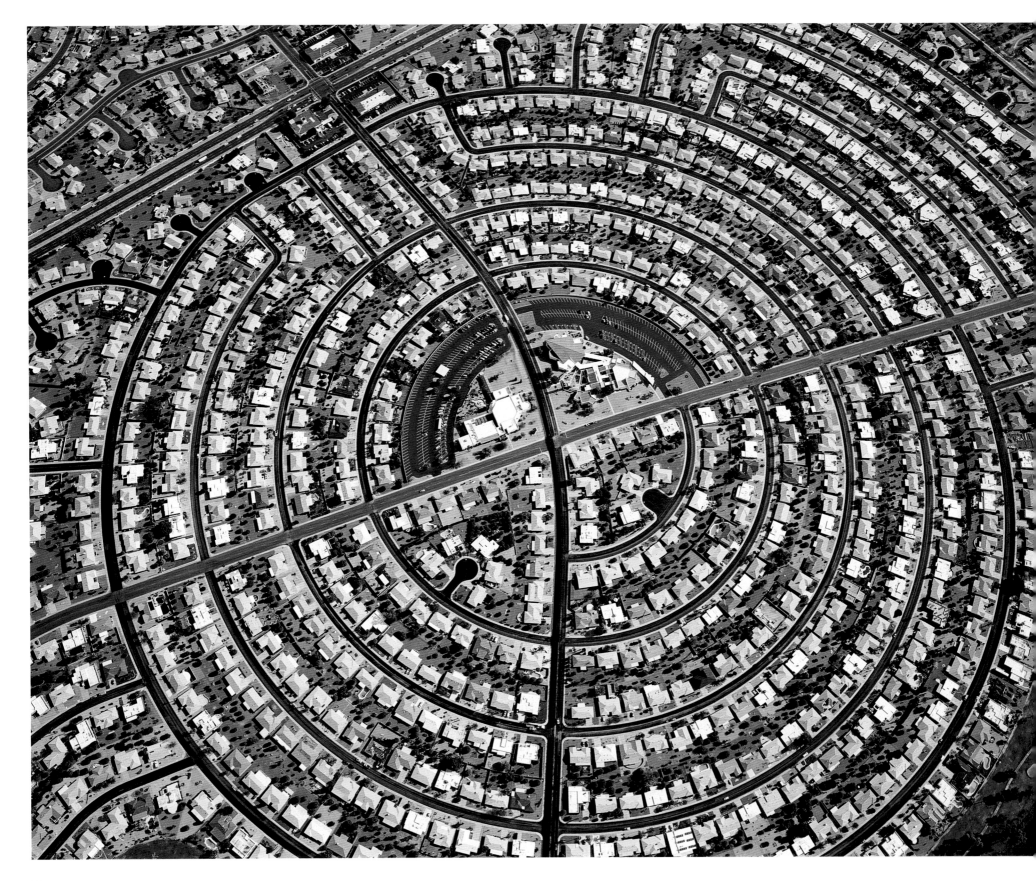

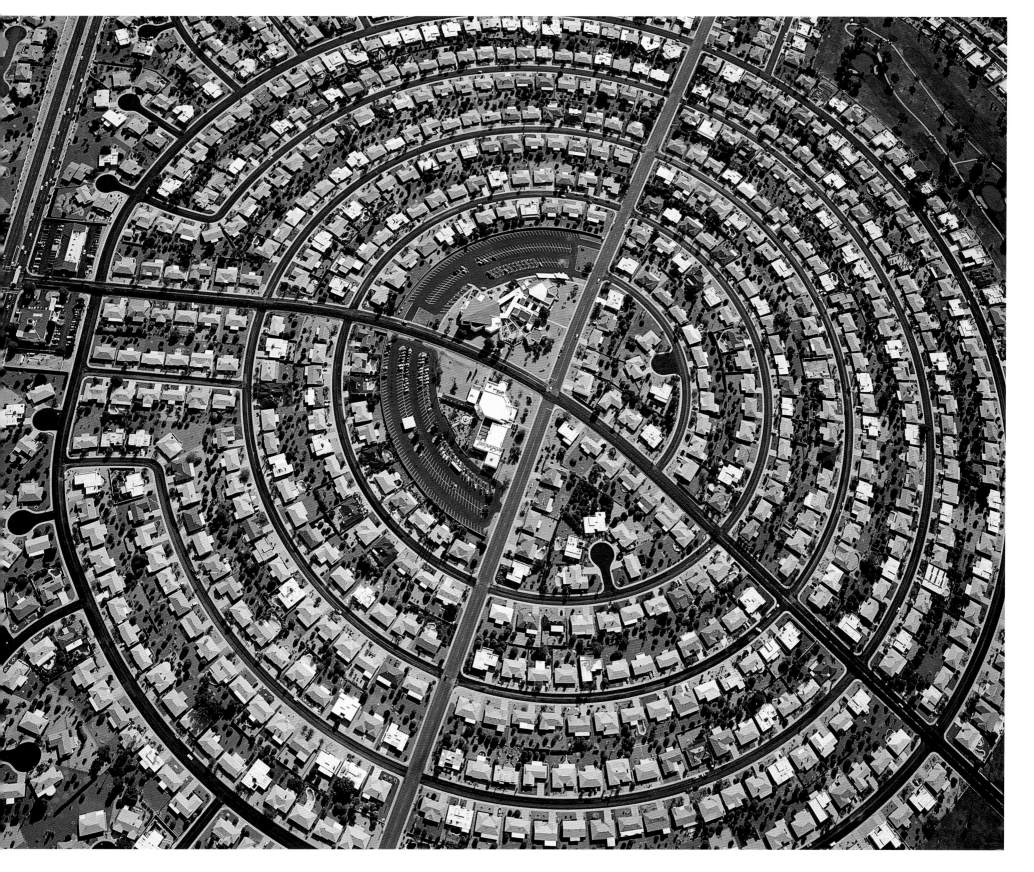

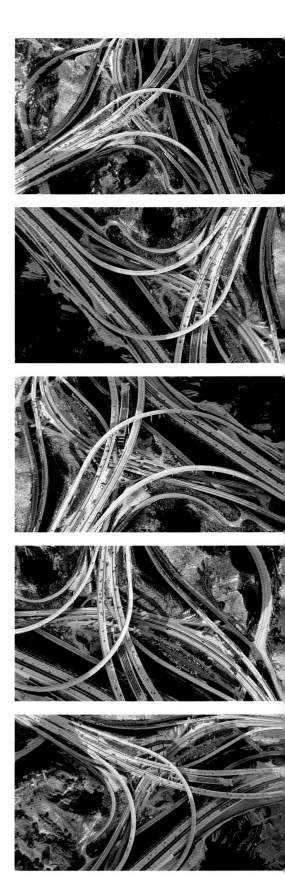

UNTITLED CALIFORNIA II Video **CONVERSIONS XXIII / XVII / XVIII** Suburban California

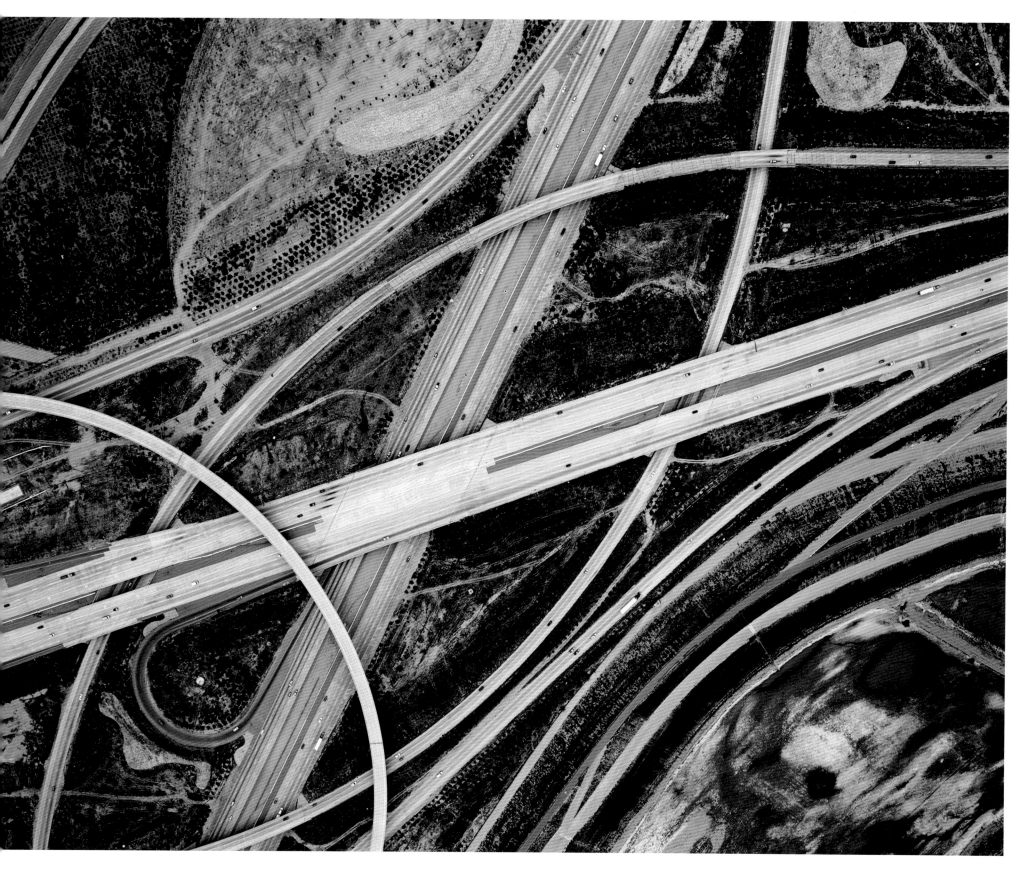

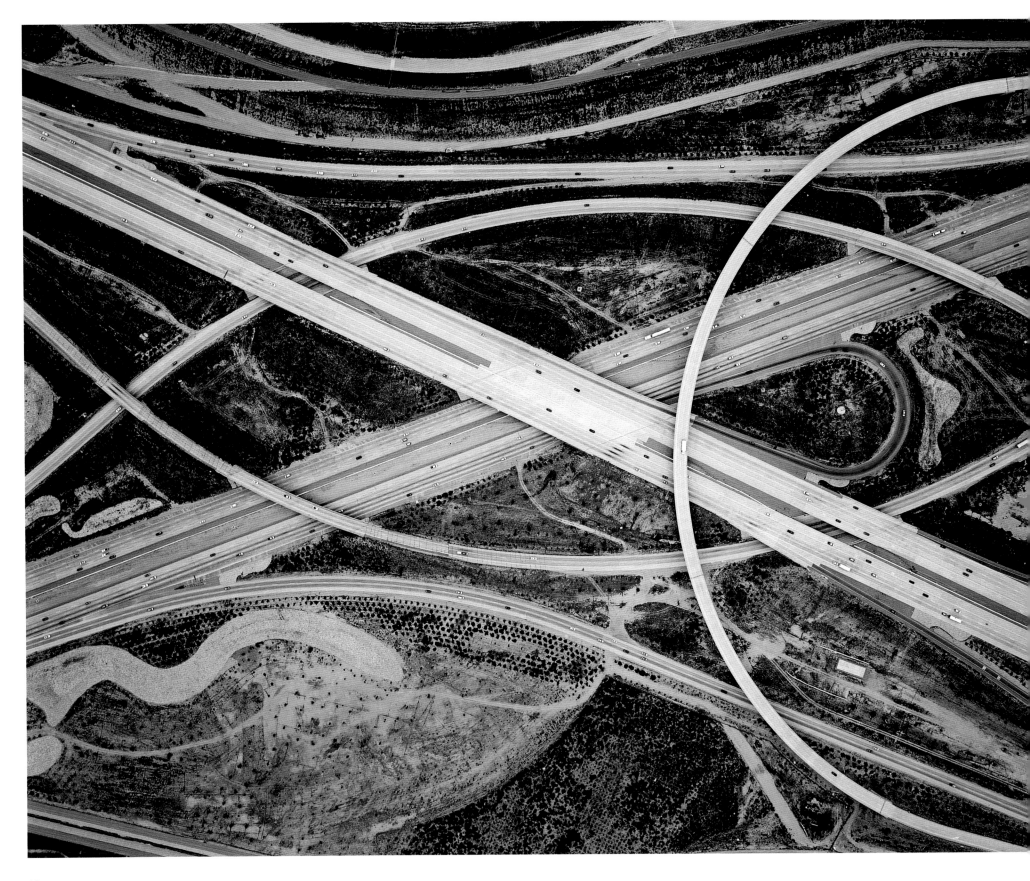

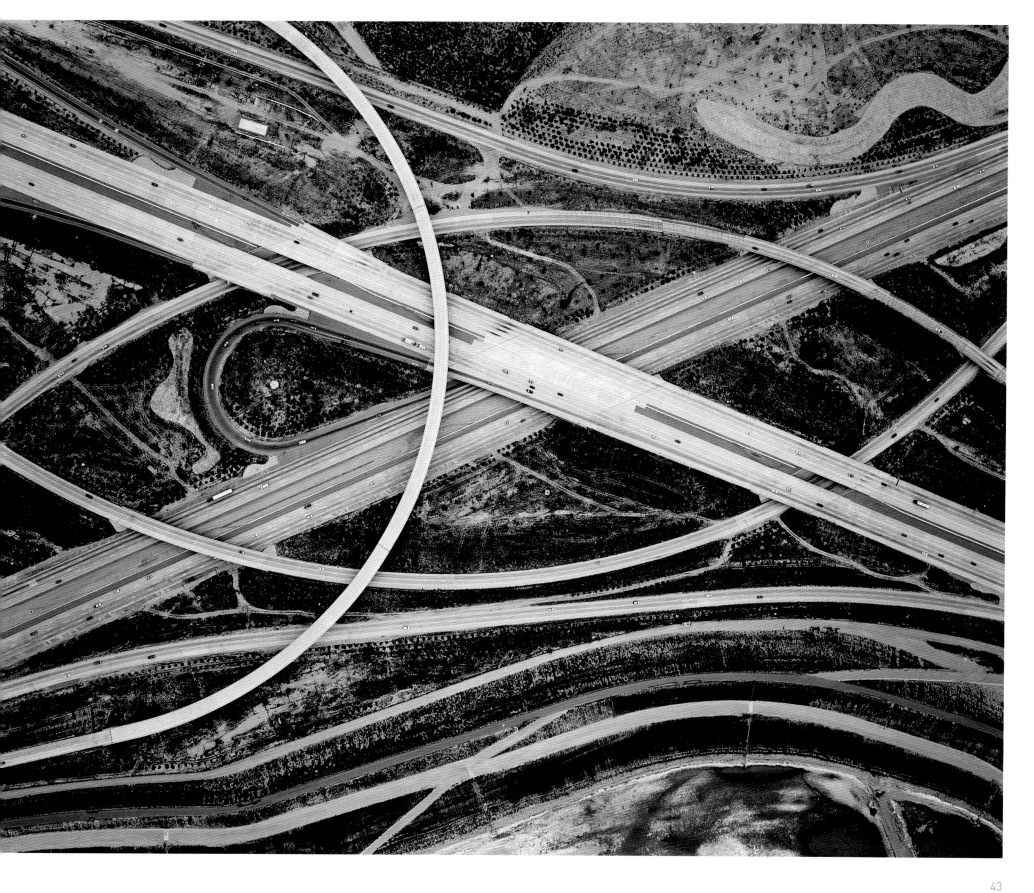

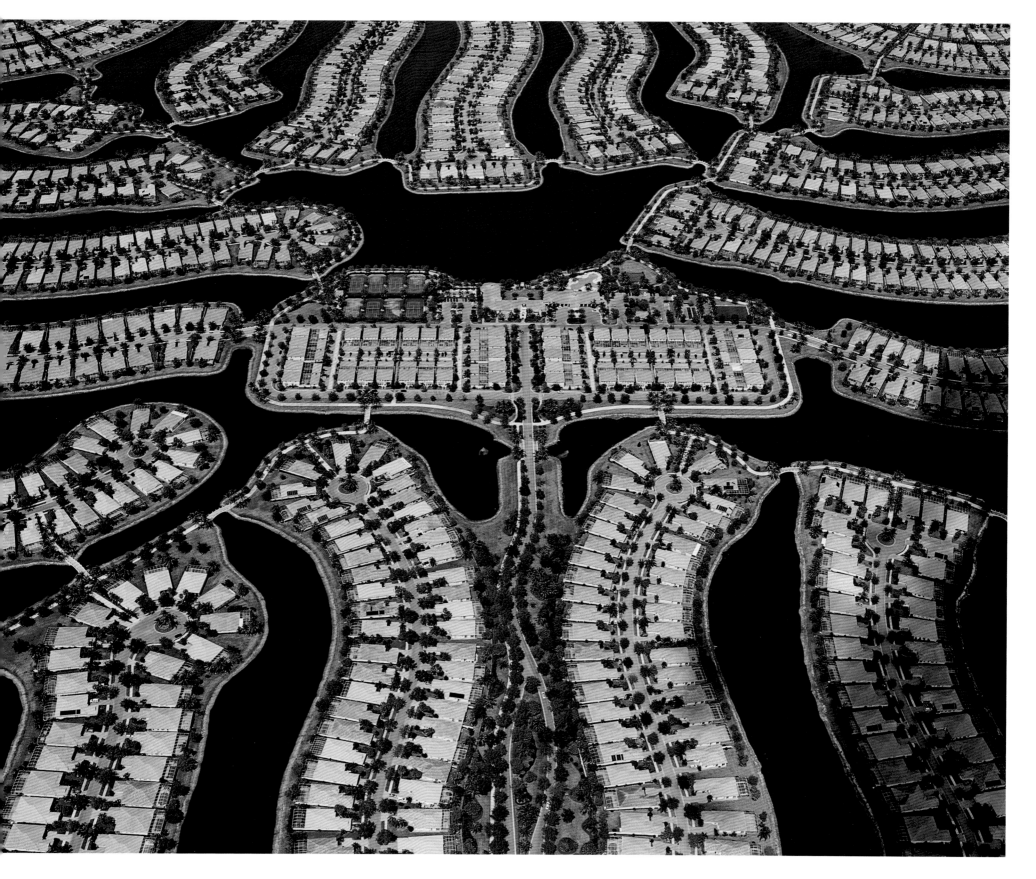

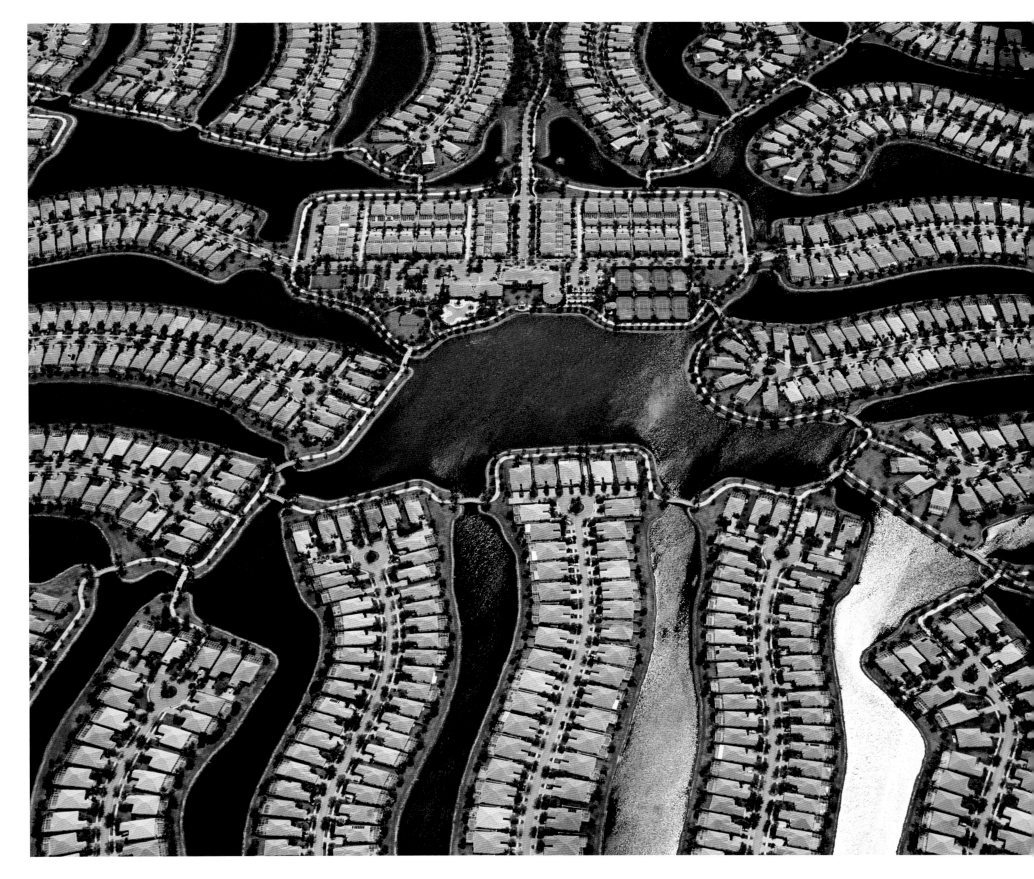

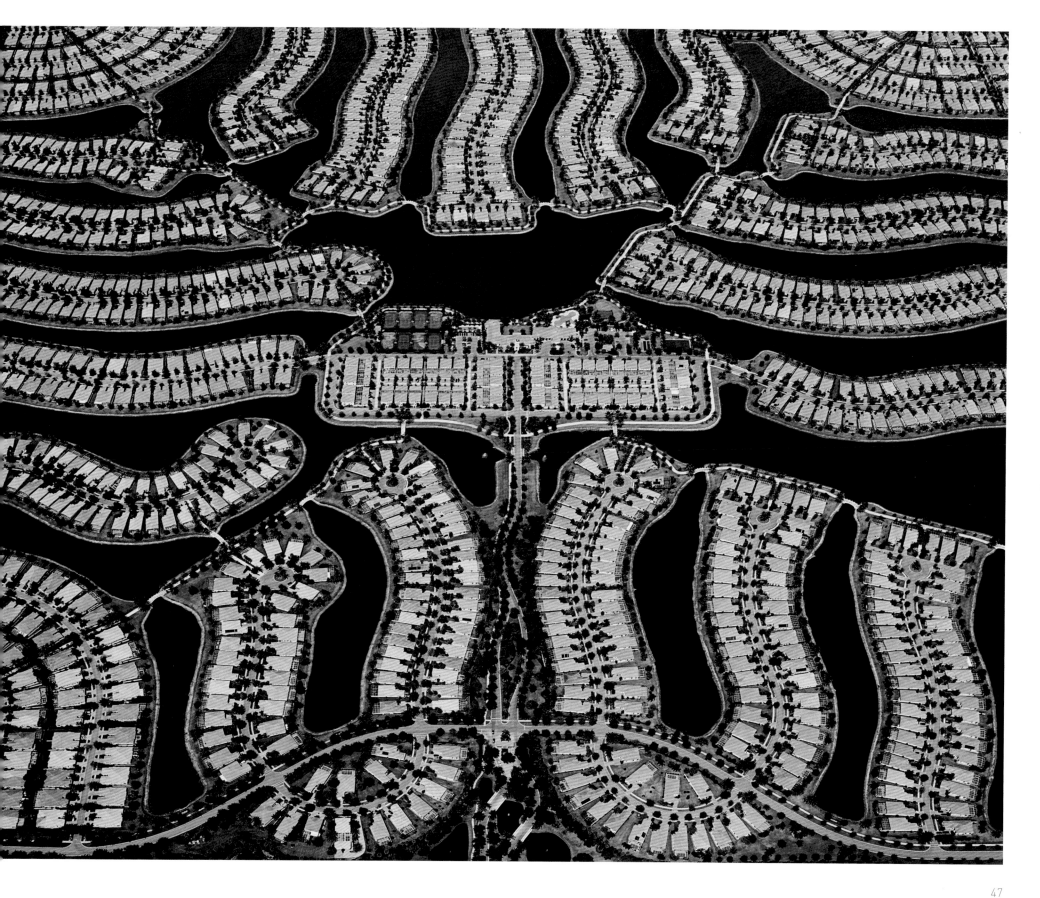

UNTITLED Nevada

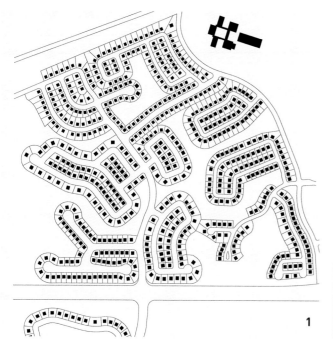

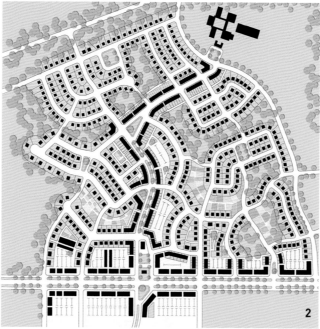

1

2

1. A typical single-use, auto-dependent residential subdivision

2. A transformation into a mixed-use village with a neighborhood center

SOLVING SPRAWL

What meaning are we to take from Christoph Gielen's photographs of sprawl? Tract homes and supporting infrastructure are visually enticing from his 10,000-foot view, appearing as intricate, mazelike patterns. But on the ground, the relentless schemata of wide streets and lawns produce a host of problems. The majority of the developments that Gielen photographs are isolated, car-dependent, and filled with single-family dwellings.

With these images, Gielen challenges us to act, to identify and correct these problems—and invites us to consider the future of our human habitat.

Countless neighborhoods, similar to the ones Gielen portrays, can be identified as sprawl. Such communities do not live up to the promise of an idyllic suburban alternative to the stress and hardship of dense city life—but have failed economically, socially, and ecologically. Yet planning practice in the United States largely continues to promote and subsidize this type of settlement pattern through codes

and policies that would make building traditional cities and towns illegal today. These trends are perpetuated despite what we now know about more efficient use of land, energy, and water. Because people living in sprawl developments require a car to reach everyday destinations, their lifestyles contribute significantly to greenhouse gas emissions, higher obesity rates, and lead to many frustrating hours spent wasting time stuck in traffic.

Recently sprawl developments, particularly in the far-flung exurbs, have suffered some of the highest rates of foreclosure. Entire subdivisions have been abandoned; hundreds of suburban shopping malls and office parks have failed since the 2007–2010 market crash. Even if the United States economy recovers, many of these neighborhoods never will. This form of habitation does not serve new and developing markets: it cannot provide the diversity and stimulation desired by the millennial generation, nor the conveniences needed by their baby boomer parents, who

are entering retirement. Furthermore, an increasing number of people are becoming aware that sprawl makes their day-to-day lives more difficult. They can no longer walk to stores, schools, or work, and so have come to realize they are less likely to have social and intergenerational interactions without first having to get into their cars.

Ironically, suburban planning was conceived with the intention to better our lives and economic growth, and was based on a clear-eyed intention to integrate the automobile into our human habitat. Destinations no longer needed to be located within close proximity to each other, and thereby, much of the United States transitioned from pedestrian-scale urbanism with small blocks and narrow streets to big parking facilities, wide streets, and highway interchanges.

Today it is clear that this transition brings with it considerable and unwanted side effects. The time has come to switch from auto-dependent and single-use monocultures to complete, human-scale communities.

Developers cannot continue to build greenfield sprawl, yet neither can the United States abandon the existing sprawl wholesale. Our only option is to repair the worst excesses of sprawl—to find ways to restructure and redefine as much of it as possible into livable and robust neighborhoods. A pragmatic, forward-thinking redevelopment of sprawl would create, within the already existing infrastructure, vibrant, walkable multiuse settlements with a number of transportation options. In addition, we need to acknowledge that while some portions of sprawl may be repurposed for human settlement, others may devolve, reverting to agriculture or nature.

Sprawl has been aggressively promoted in North America—therefore, the approach used to repair communities with potential for redevelopment should also be aggressive. Repair should be pursued comprehensively, based on urban design, regulation, and strategies for funding and incentives—the same instruments that originally made sprawl the prevalent development form. Repair should be addressed at all urban scales: from identifying potential transportation networks and creating new transit-connected urban cores to transforming dead malls into town centers; from reconfiguring conventional suburban blocks into walkable fabric to the adaptation and reuse of single structures.

An alternative to evolving sprawl by reconnecting its urban fabric is to "devolve" it—leaving sprawl as is, or shrinking it to a smaller urban footprint, into farmland or even into open spaces. It is inevitable that certain community developments will be less physically and economically feasible to evolve. These are the more isolated, disconnected, exurban fringes that can be seen in Gielen's cluster of desert homes taken in the Southwest (*Untitled IV Nevada*). If residents and businesses were to migrate en masse from these fringes due to unemployment, foreclosures, or social instability, then they may well be transformed back to agriculture or nature. The "shrinking cities" initiative focuses on programs for managing the reduction of the physical footprint of areas experiencing economic and population decline.

Devolution can be applied at a smaller scale as well, where deserted properties can be replatted to larger lots and used for community gardens or larger family compounds.

Areas where the crisis is most acute—where long commutes, traffic congestion, falling real estate values, outdated infrastructure, and lack of public amenities become unbearable—should be given precedence for sprawl repair. Ideally, priorities for evolution or devolution must be set at the larger, regional level, and then addressed at the community scale, where residents, associations, property owners, and developers can make decisions locally.

Sprawl must be fixed. This will not happen in one sweeping grand gesture, or through vast amounts of public and private resources as prior economies allowed. Sprawl repair will be an incremental and opportunistic improvement of our suburban landscapes and will happen in neighborhoods where economic potential, political will, and community vision converge.

Galina Tachieva

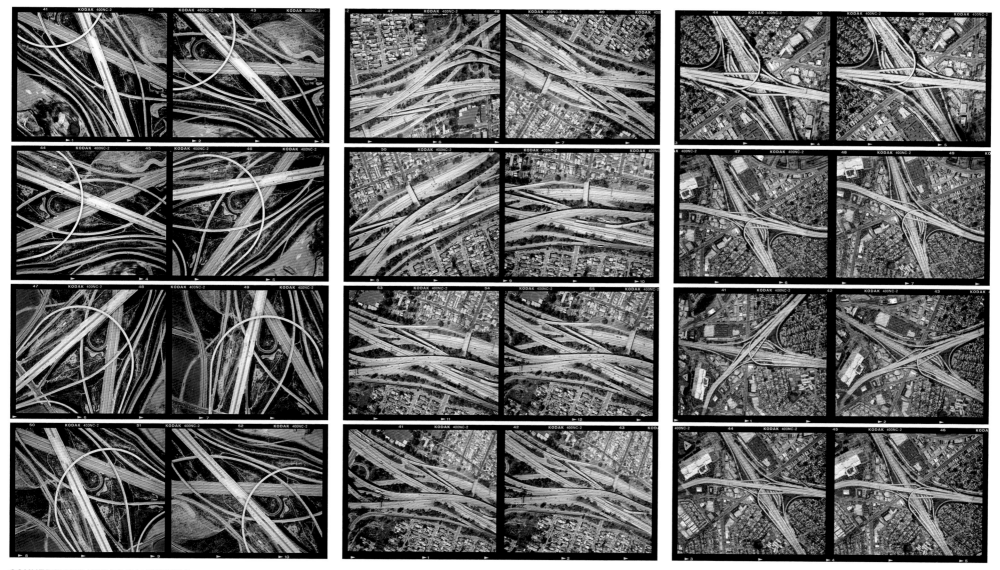

CONVERSIONS URBAN CALIFORNIA

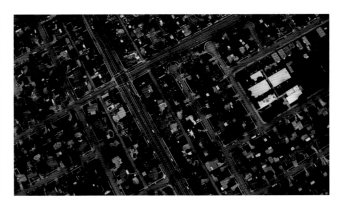

IMAGINARY INHABITATION

The more I look at the photographs of Christoph Gielen, the idea persists that his project to rethink the priorities of inhabitation transitions from reality to fiction. This is done through a visual freeze of images that cannot zoom in or zoom out. These photographs of properties depict some that are realized and others unrealized: prisons, highway exchanges, socialist housing blocks, urban China, dust, and images of housing demolition. Slid into the pages in between are images of whirling water that add punctuation and further disorientation. The photographs that were taken in the United States are from high in the air, those from East Berlin are from mid-air, and the shots of China are from the ground. In the United States, the angle is often nearly straight down as seen in the photographs of swirling nodes of American suburbia. Yet, as it acts like a seismograph, the camera angle swings like a pendulum. The vertical views reveal suburban patterns of mesmerizing geometries. The oblique views record a loss of the sense of geometry just at the angle that provokes unease. This is best seen in the *Outer Houston I / II / III Texas* aerials. These auger what systemic and social "earthquake" we are about to find on the ground. Just when the camera is about to reach below the roofs we are pulled back—like a pendulum—up where nothing of the damage on the ground can be felt.

At first glance, thinking of inhabiting this geometry can take the viewer into both the past and the future—both times when the real and the imaginary part ways. However, the history and the use of this geometry is still partial. Suburbia shows that it is not history. For the New Urbanists, the main culprits behind "fixing the future" of suburban life, the project of suburbia is not at all over. In fact they say that this project "is working," and it needs to be finished. This is the moment when we leave the real and enter a serious speculation, an imaginary inhabitation, a more solid fictional construction that for some reason has more measure than reality. Gielen's visual freeze captures the uncertainty of time to ask: are we looking into the history or the future of inhabitation? Or is it not possible to answer this question because the history and the future are mixed up, blurred to the point that they are beyond oppositions. Past and future are rather degrees of each other, and as such enter the realm of speculation, the imaginary, and even fiction. This type of fiction is like Freud's notion of a screen memory, in which the memory of childhood is quite different from the events of childhood itself. Understood as such—as fiction—Gielen's visual freeze can be used to relate diverse camps within theory, practice and education in architecture and urbanism not as opposites, but as degrees of each other. We can easily imagine a story of an imaginary and fantastical affair in a futuristic science fiction novel written by Bruce Sterling, or a new kind of timeless black comedy like *A Serious Man*, the film by Joel and Ethan Coen, set in any of the living radii of the suburban geometry.

Indeed, for the New American Urbanists, the terms of inhabitation are indisputable, sincere, concrete, substantive, and axiomatic just like geometry. Furthermore, the New Urbanists' goals are so clear and systematic as to appear natural. The pre-war, i.e., the pre-automobile American nature is the axiom. The most circulated document promoting this goal is called the SmartCode developed by the "Center for Applied Transect Studies." It is a document, a code for Urban Design that can be downloaded for free and used by municipalities. Its "smartness" lies in the proposal to design inhabitation according to the pre-war American sequence of nature from the ocean to the vegetation in the back dune. That natural sequence is called *a transect*. "A transect is a cut or path through part of the environment showing a range of different habitats. Biologists and ecologists use transects to study the many symbiotic elements that contribute to habitats where certain plants and animals thrive." The original idea was created by Alexander von Humboldt at the close of the eighteenth century. Today, as the authors of the Smart-Code claim, before the automobile, this natural transect in its untouched form consisted of ocean, beach, primary dune, trough, secondary dune, and back dune. The New Urbanists thus propose to organize human inhabitation patterns in a similar way and have designed an inhabitable transect typology that includes all of these zones. Municipalities can follow this manual with the freedom to change some of the parameters, usually of density and distribution of class. By offering a "free transect," which is a sequence of sectional codes, New Urbanists become not only coaches for implementation but even dictate the future, diverging from typical urban designers who mainly operate reactively. Numerically speaking, by lowering the density to avoid sprawl, this code places land under higher pressure for private developers, who find curvilinear ways to increase the number of lots, fronts, and

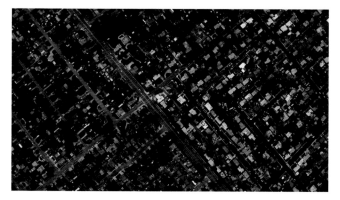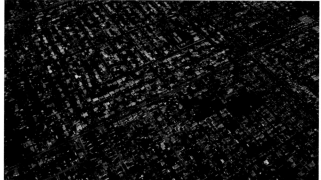

UNTITLED CALIFORNIA V Video

backs. Geometrically, by distorting the traditional grid of the sprawl, the rectangular lots become overlapped and thus individually smaller cutting across previously rectangular angles to decrease the space in between the houses. Imagine two rectangles of property next to each other in a traditional grid. When the grid is warped, the rectangles overlap. Due to the overlap, each property gets trimmed by half of the overlapped intersection, thus becoming smaller in area. The whirly-shaped results of packed "natural" patterns are simply more profitable. The fiction becomes even more unreal as those patterns are compared to natural patterns—like the comparison of such suburban street geometry to the packed pattern of a ficus leaf.

Hence curvilinear street geometry is indeed a numerical speculation, a carefully crafted fiction left open to imagination. Interestingly, Gielen's photographs of suburban geometry are given fictional names. This originates from the beginning of his process when he is perusing the properties with real estate agents on the ground. With the names he assigns his photographs, he doubles the falsification employed in the naming schemes of the designers. As he says, the designers' attributions are always faux, but evocative of nature, and typically reference something long gone from the actual place of the development, like "meadow" or "orchard." Thus, the fiction is already embedded in the image even before the artist makes the artwork. Gielen collects all of these names and then makes random composites of them, such as: "Forest Glen," or "Deer Crest." The renaming again doubles the mimicry that has already been created on the ground.

Why is this use of imaginary inhabitation of large-scale geometry at once unusual and important? The amalgam of systemic lines, curves, and open areas that make the aerial look of suburbia degrades architecture below even its most basic definition to create shelter. This makes livable objects homogenous, devoid of oppositions and dissent, with only degrees of size and value. Thus Gielen's work leads us to a different capacity for understanding geometry in urbanism, not in opposition to fleeting confections market-labeled as "stunning architecture," such as the majority of suburban construction, but as a degree of what architecture and urbanism together can contribute to make life a bit better by design.

Architecture that is a design able to contribute to a somewhat better life does not figure in the geometrical schema of a highly orchestrated bond between natural and numerical urbanism. Gielen's manipulation of the names of places he photographed suggests that the only way architecture can enter this scene would be through subversion—by implementing a technique that is outside the normative approach to urban design. On the other hand, Gielen's photographs of urban China do not need a subversive strategy. There, Gielen does not need a helicopter. Gielen's view from the ground is analogous to his use of the aerial shot in the United States. The massive and extruded housing schemes concocted by Chinese developers, which are played out on vertically warped surfaces, resemble the geometrical manipulation of curvilinear streets of North American suburbia.

Speaking of the subversive nature of Gielen's photography, we should mention one attempt at subterfuge to invert the building explosion of suburbia, which has been going on in China. The project is called *Ordos*, and it is initiated and planned by artist Ai Weiwei, a formerly imprisoned dissident in his own country. The artist managed to "hijack" a small part of a commercial plan for one of the many new cities in Inner Mongolia and adapt the urban scheme. In *Ordos*, Ai replaced the commercial lots with a different set of smaller lots and invited one hundred younger architects from around the world to each design a villa. However, not everything could be changed. Ai had to keep the planned street geometry as it was, which appears nearly exactly the same as the warped suburbia of North America.

Gielen's work anticipates a subversive role for architecture in the future of suburban planning. Namely, by looking at geometry not merely as a mechanical process to warp form, Gielen's project opens up suburbia to a vision of geometry as a conceptual tool for inhabitation. Data already plays an important role in the complex formation of suburbia and of the financial monitoring of its citizens. Yet, dissent can always erupt and eventually become the new norm.

Whatever the case, given all the strategies, geometries, theories, and techniques, as well as data at our disposal as architects and urbanists, one question remains: How do we find inhabitation for everyone on the planet? Christoph Gielen provides a telling glimpse of the present impasse to this goal. And for those who think that this goal has already become imaginary or those who are too sincere about it, this work offers new unapologetic openings.

Srdjan Jovanovic Weiss

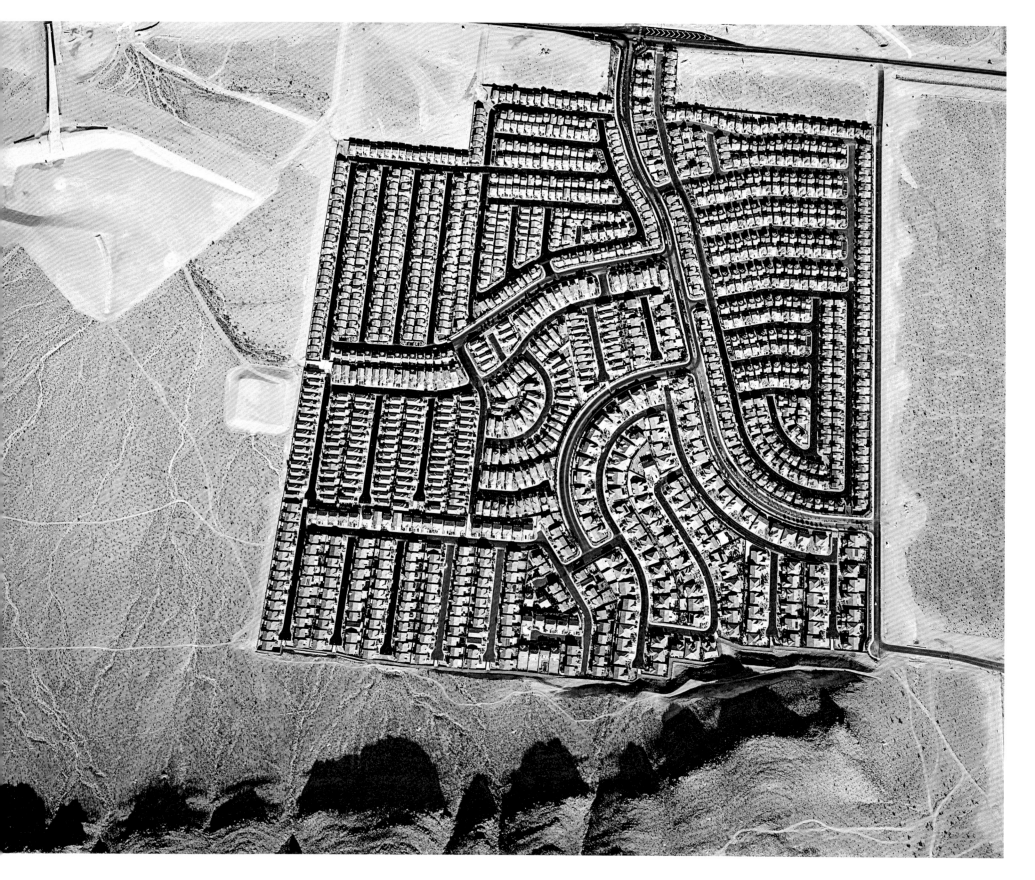

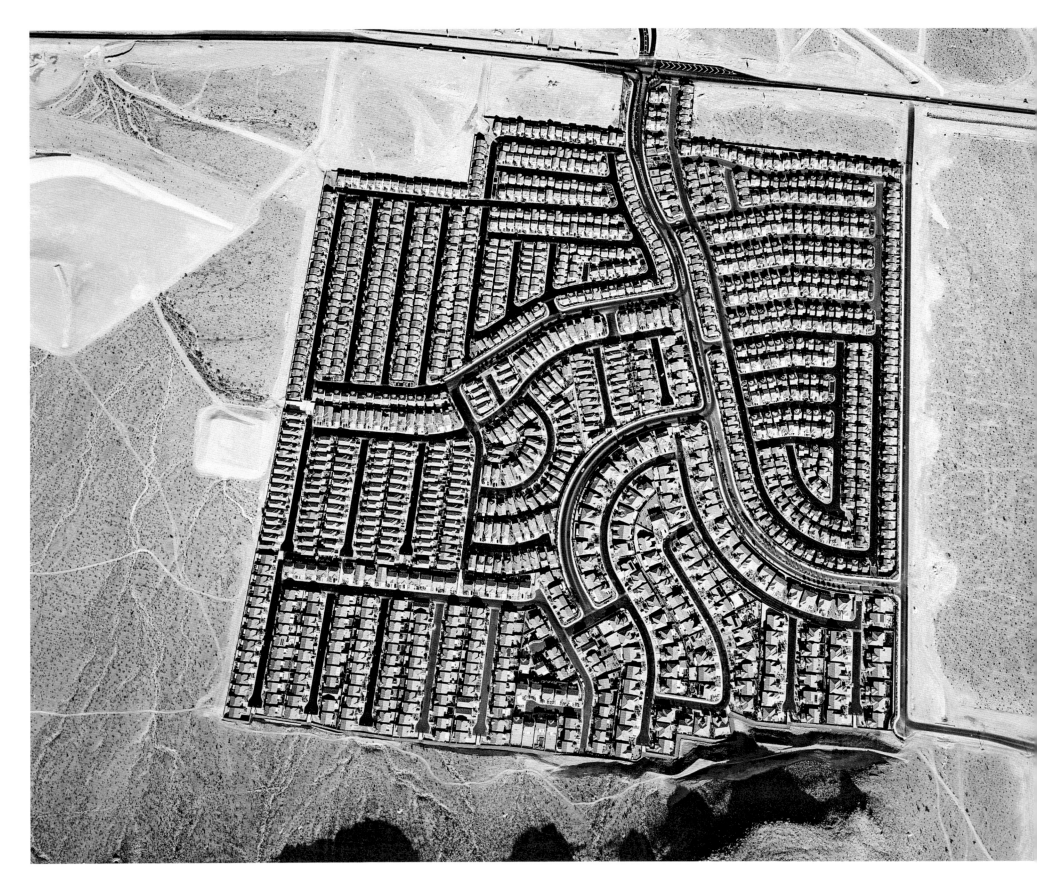

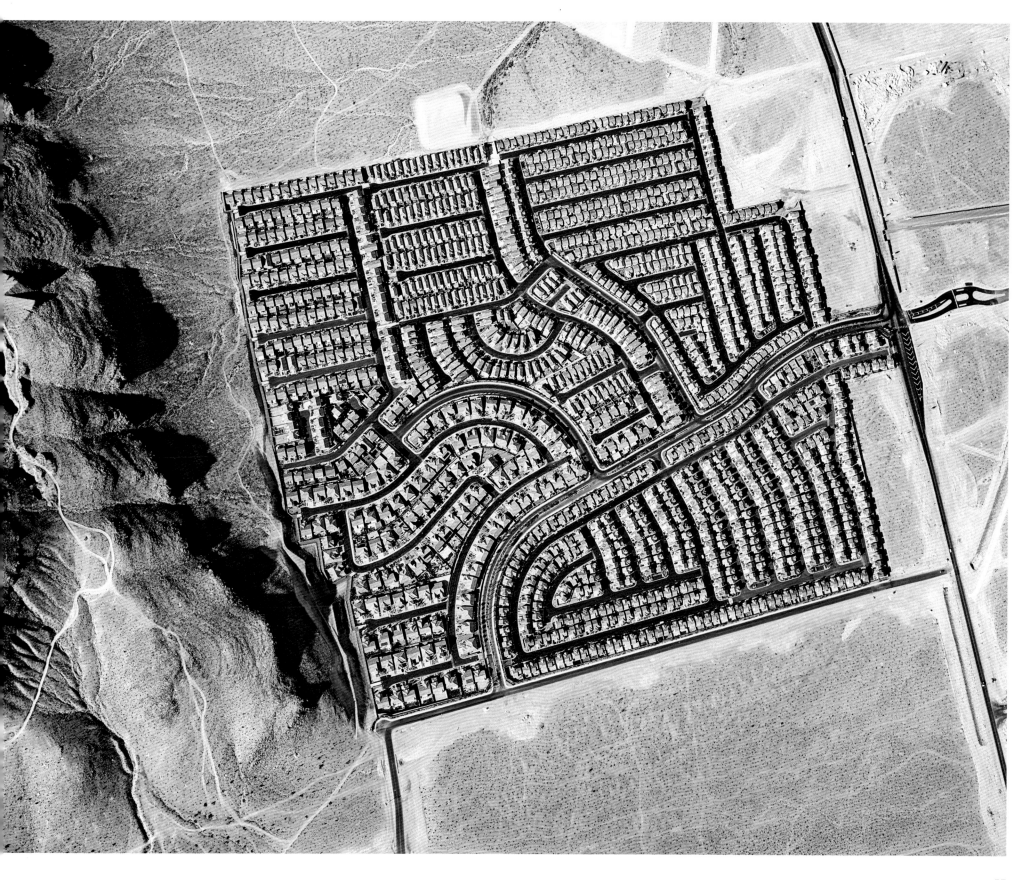

UNTITLED I / III / IV Arizona

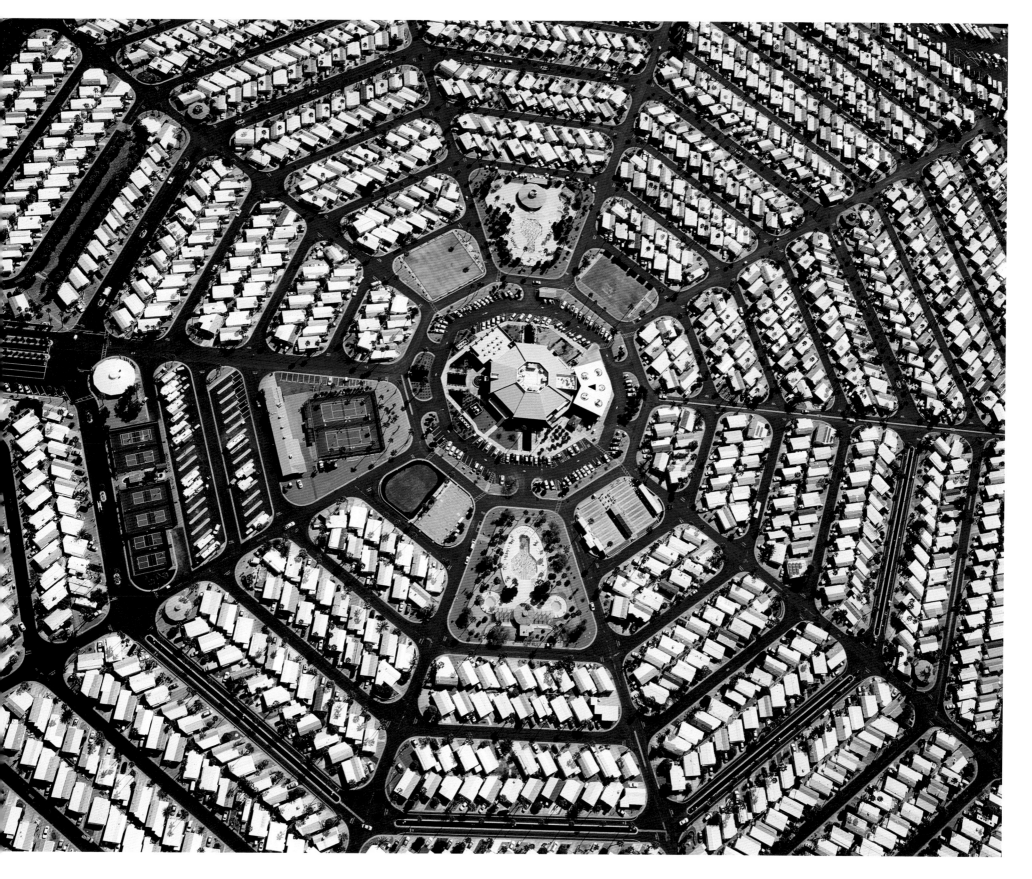

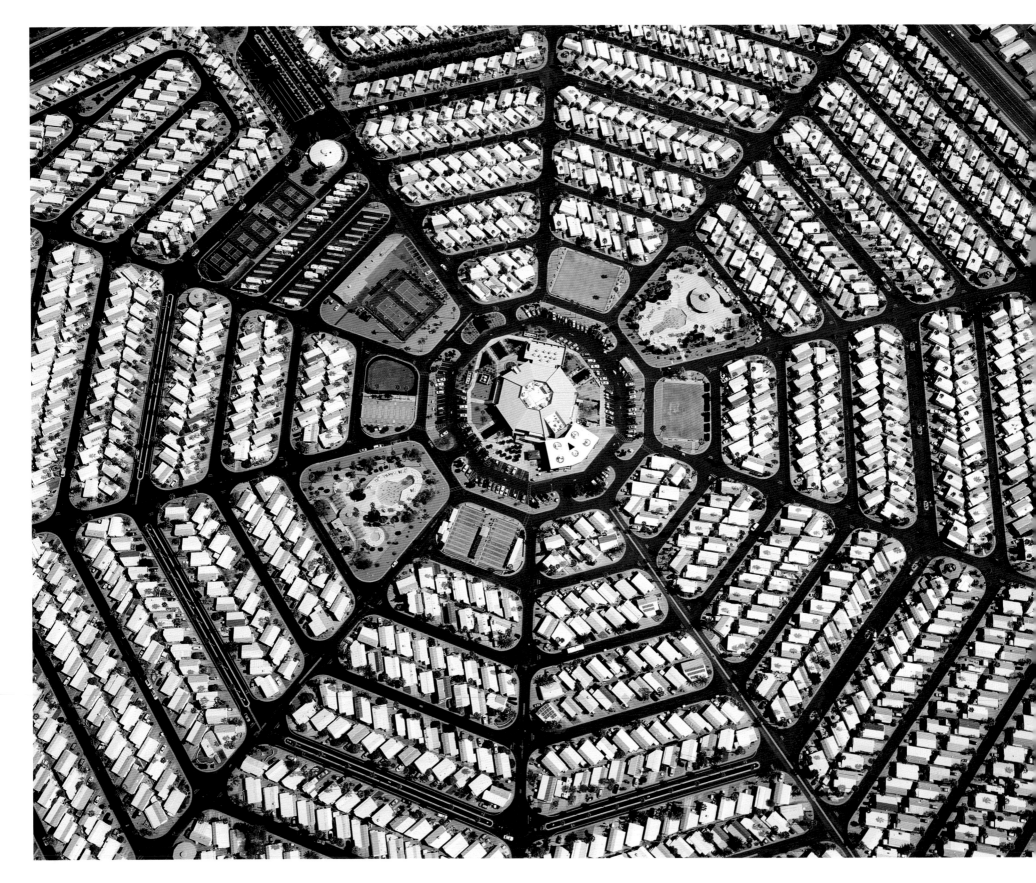

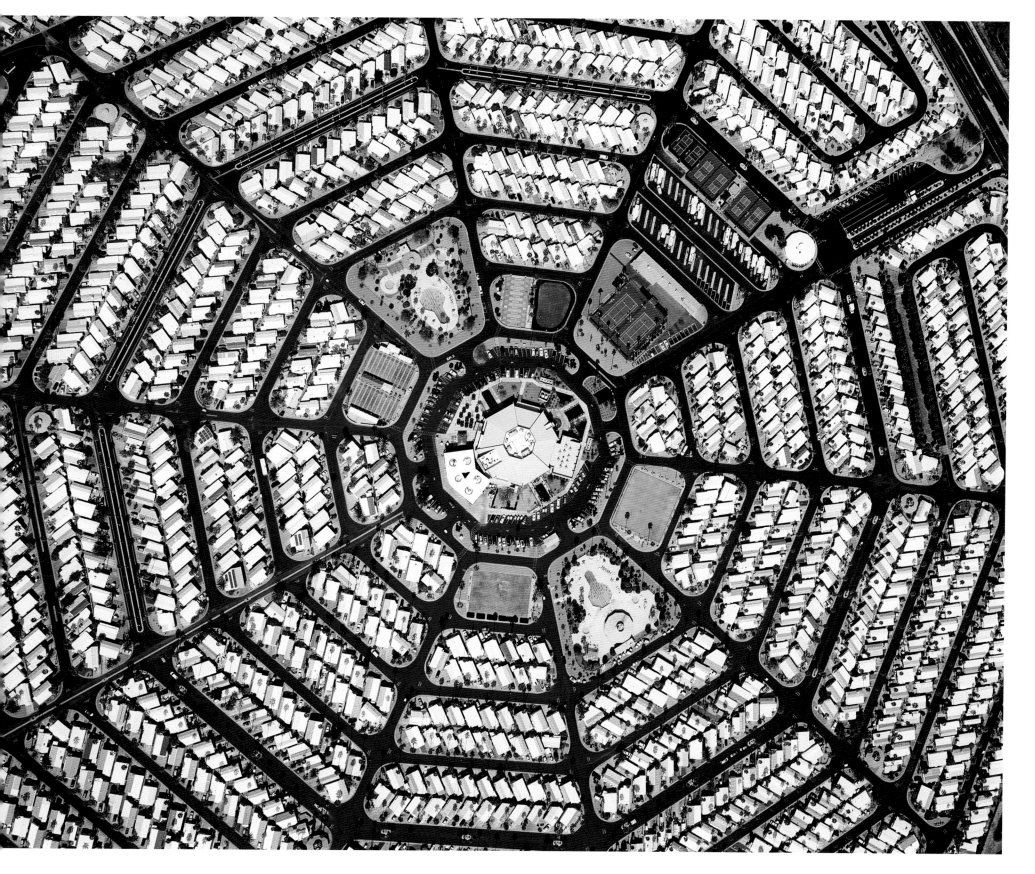

UNTITLED CALIFORNIA I Video **DEER CREST V / III / II** Suburban California

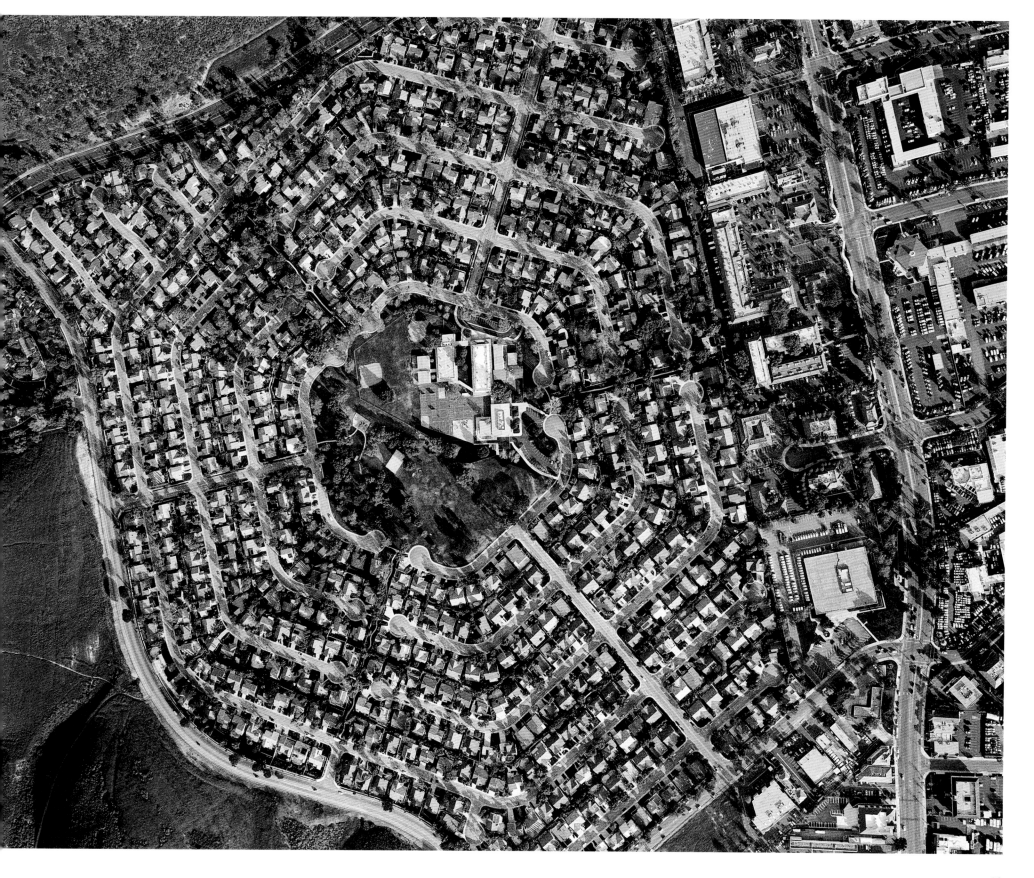

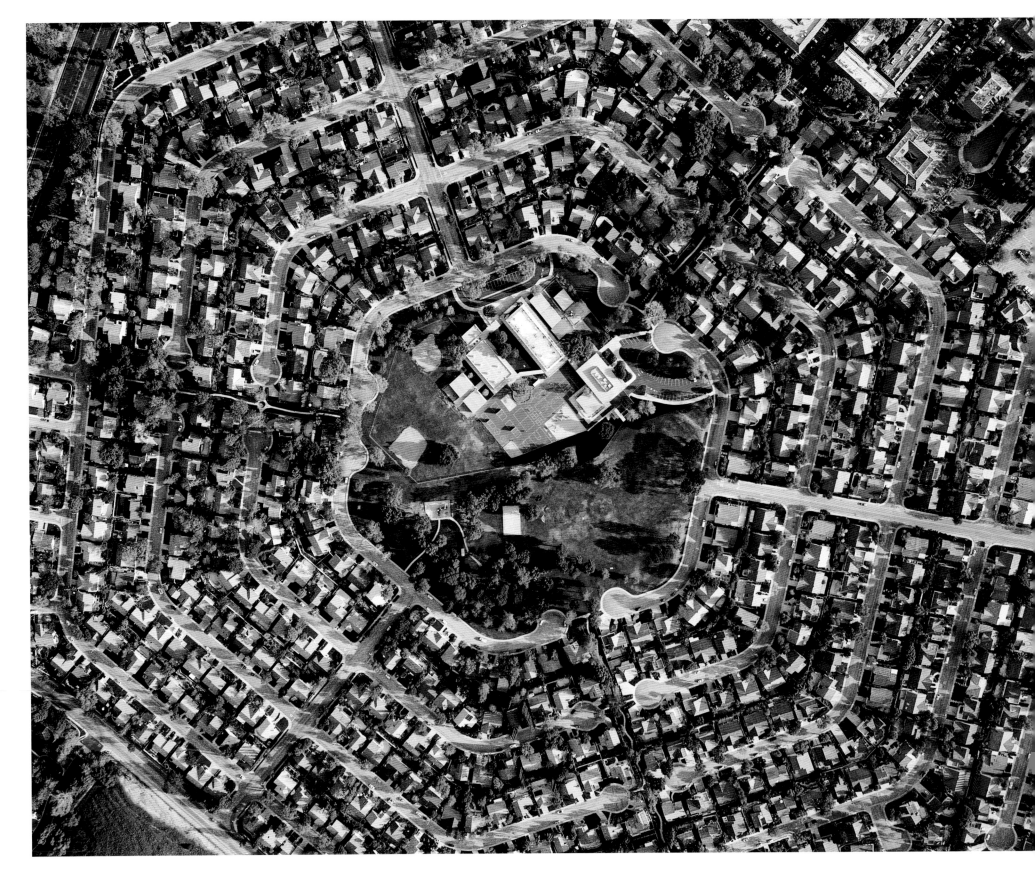

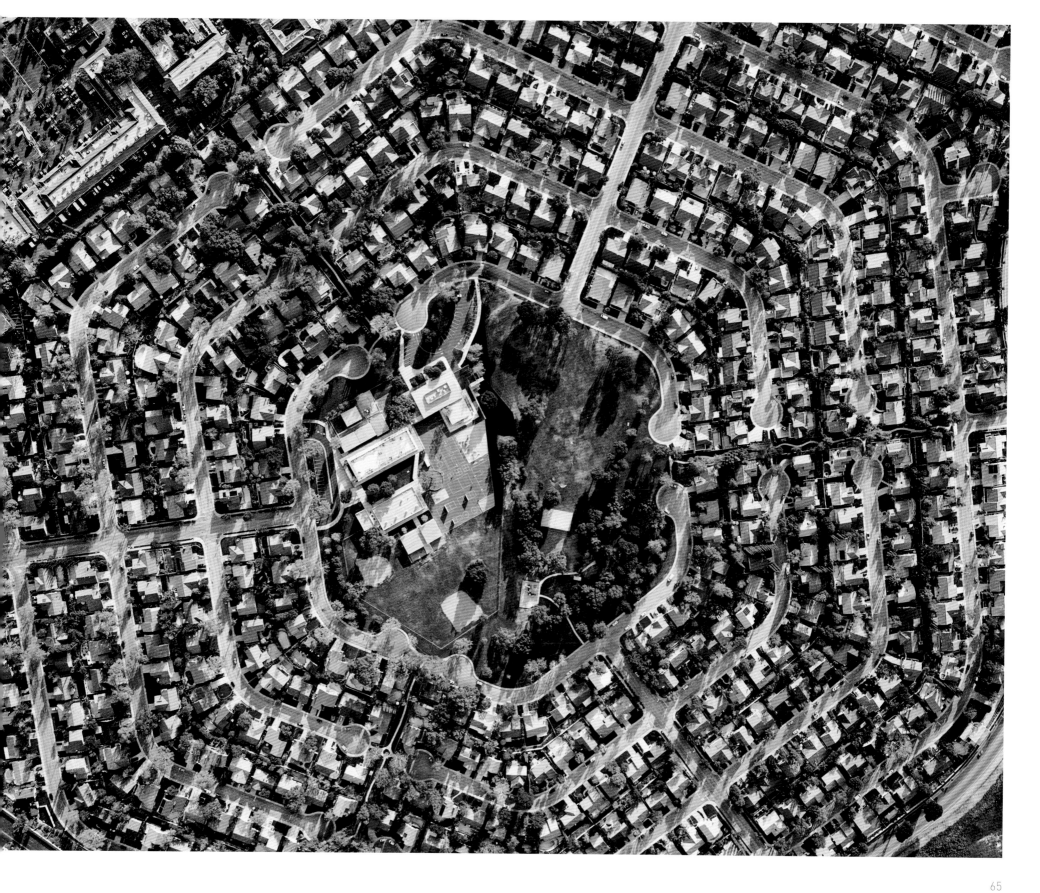

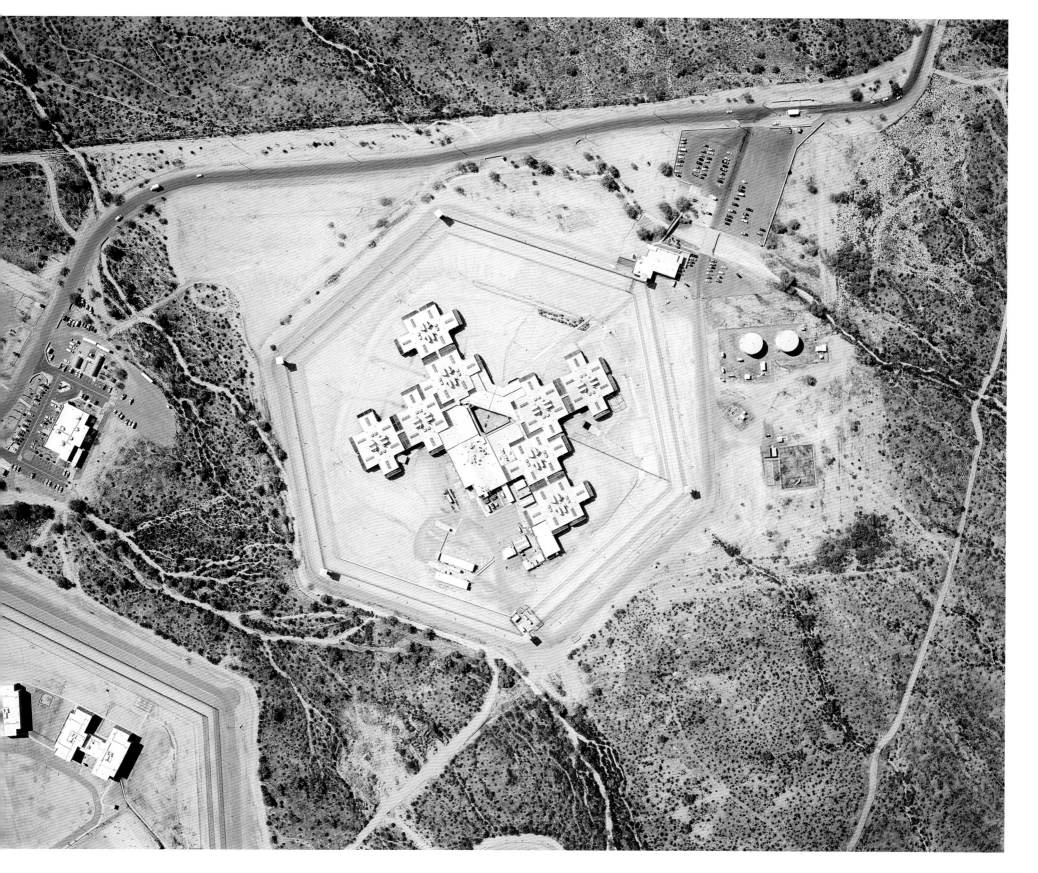

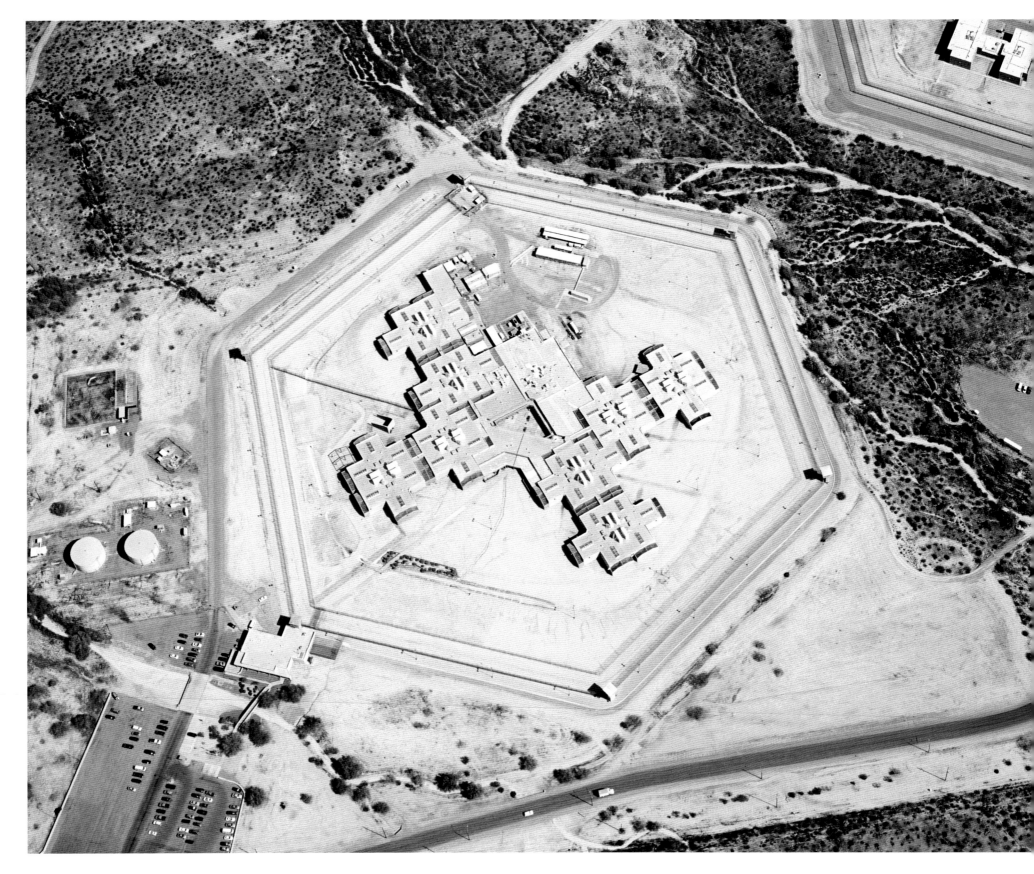

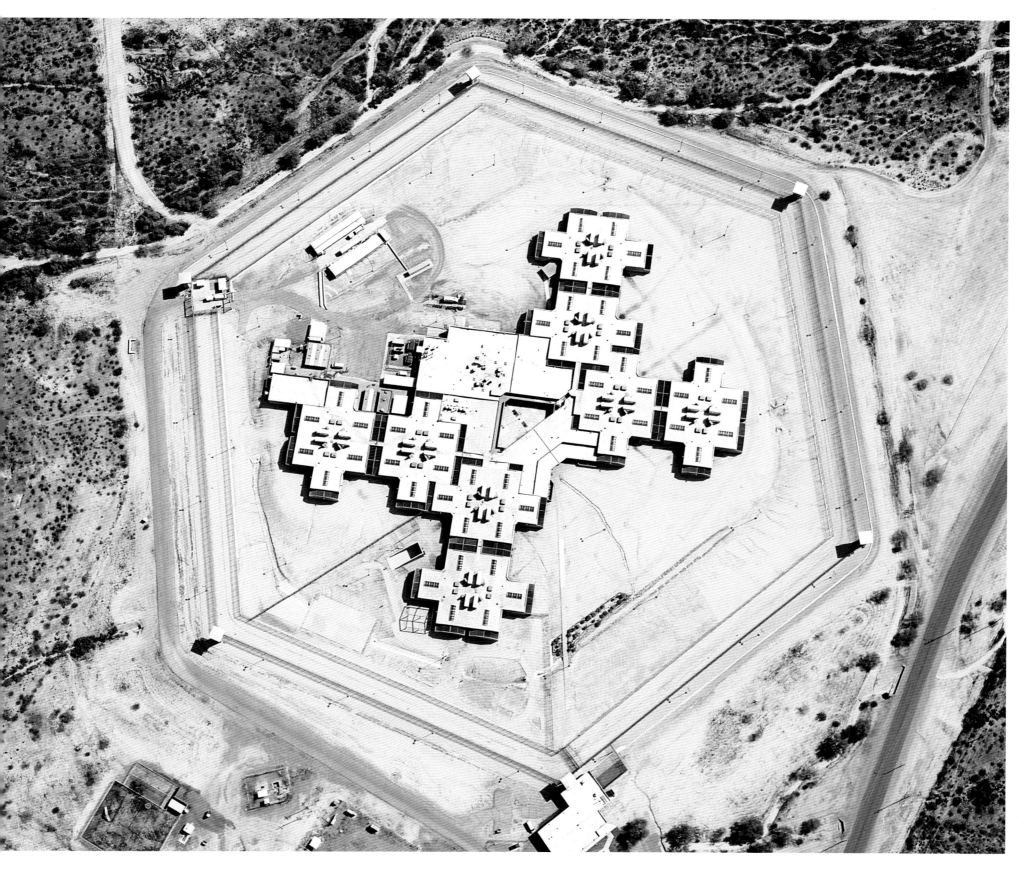

UNTITLED ARIZONA XIII / XVIII / XIV Arizona

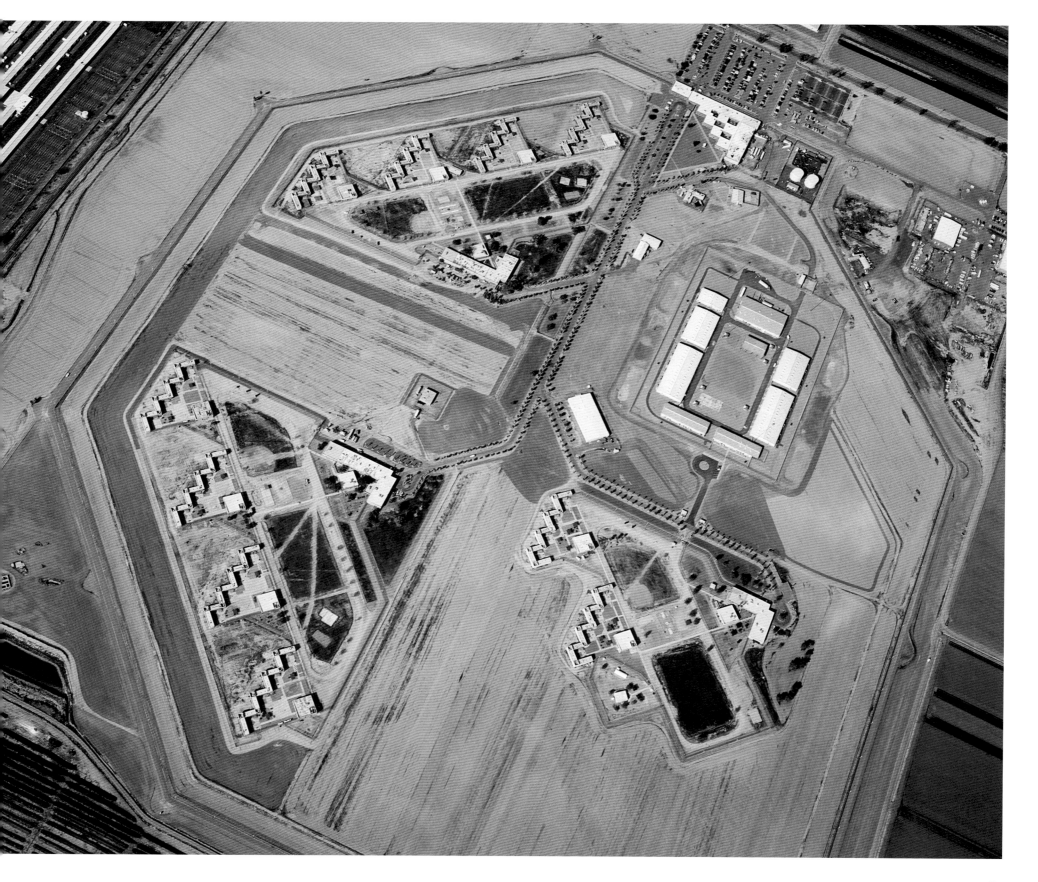

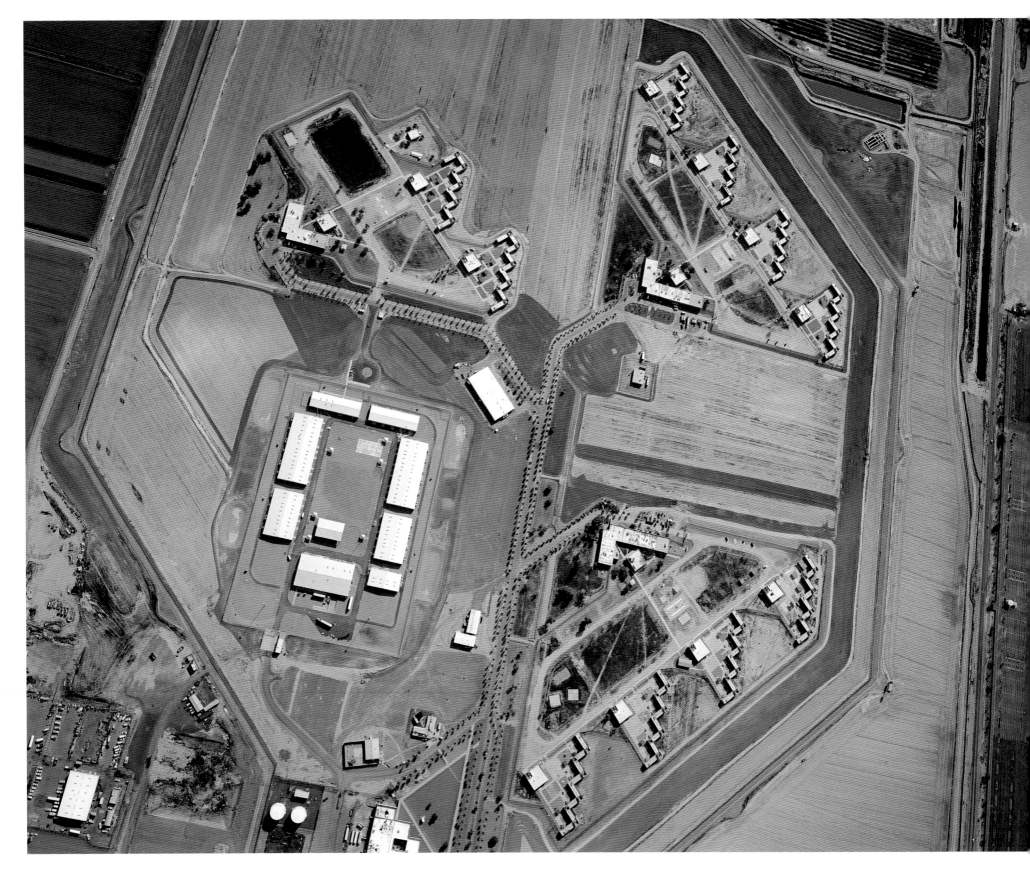

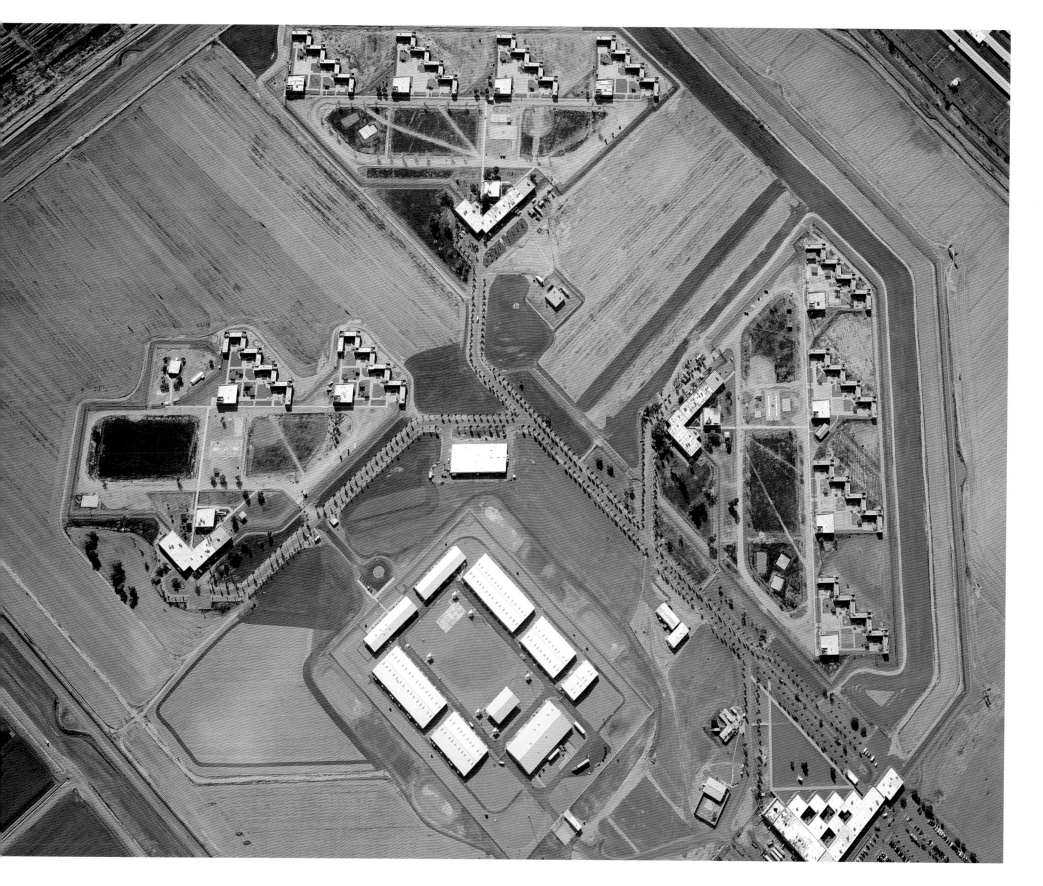

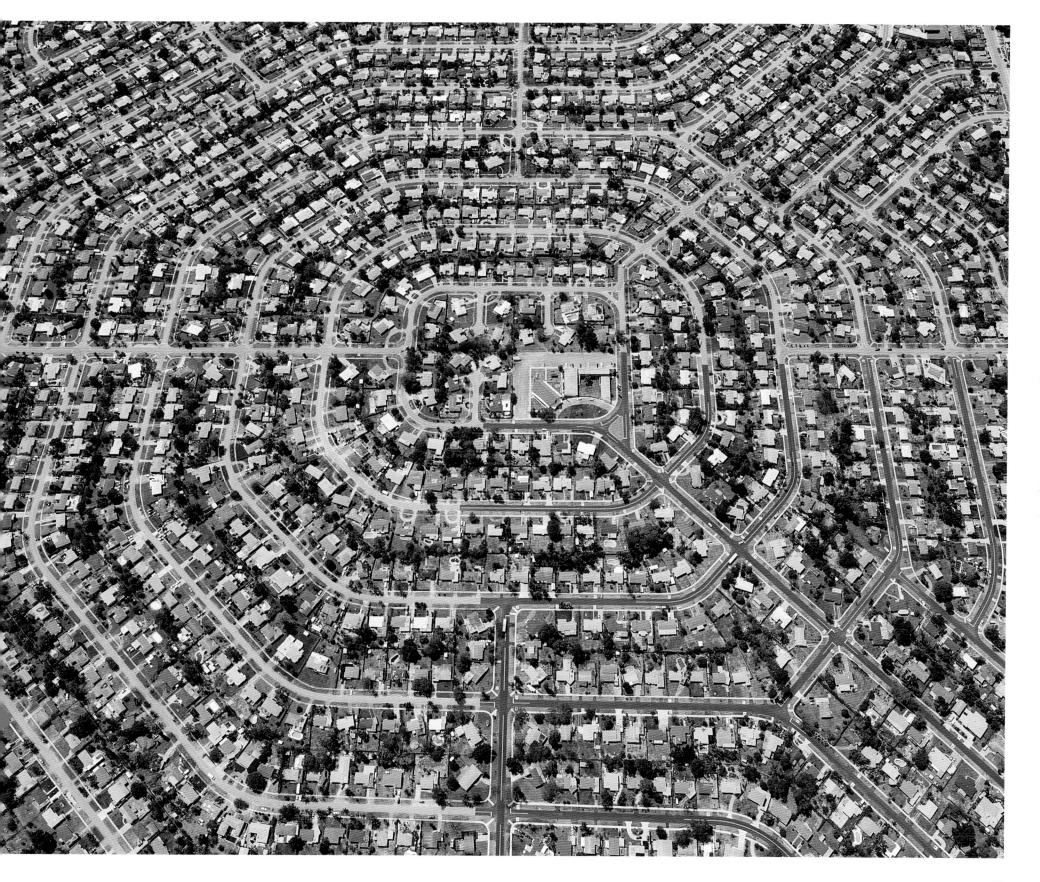

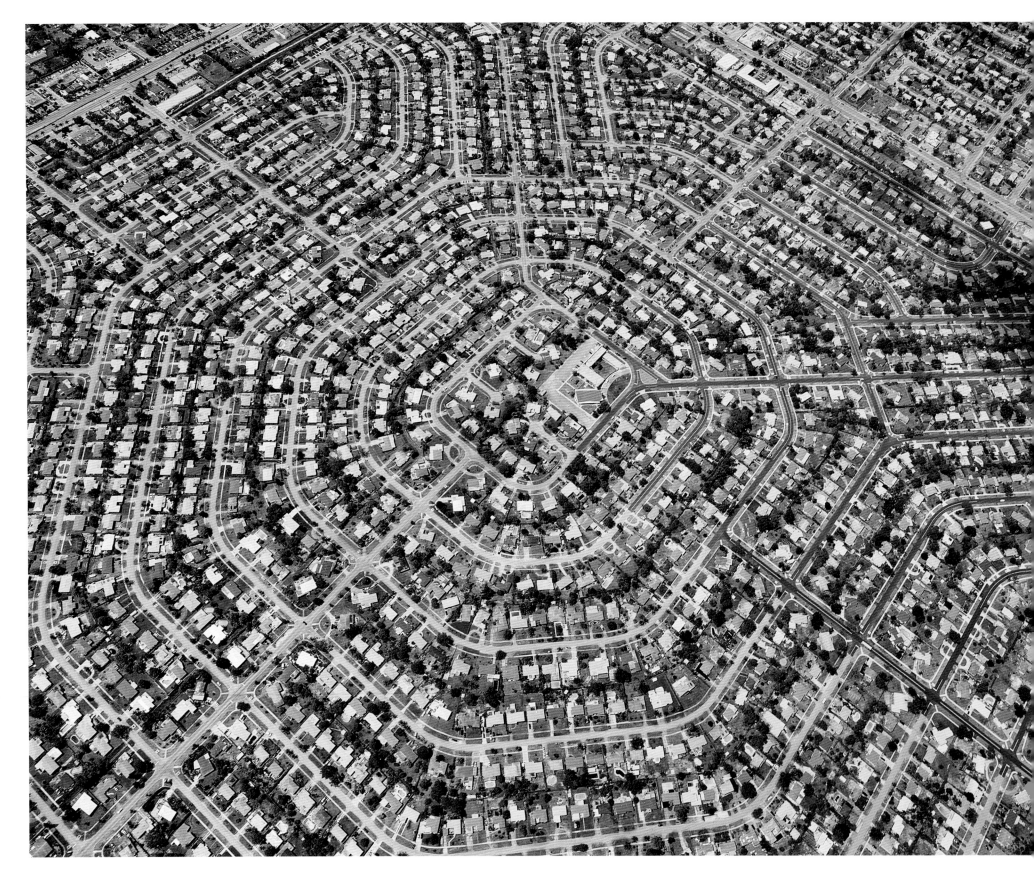

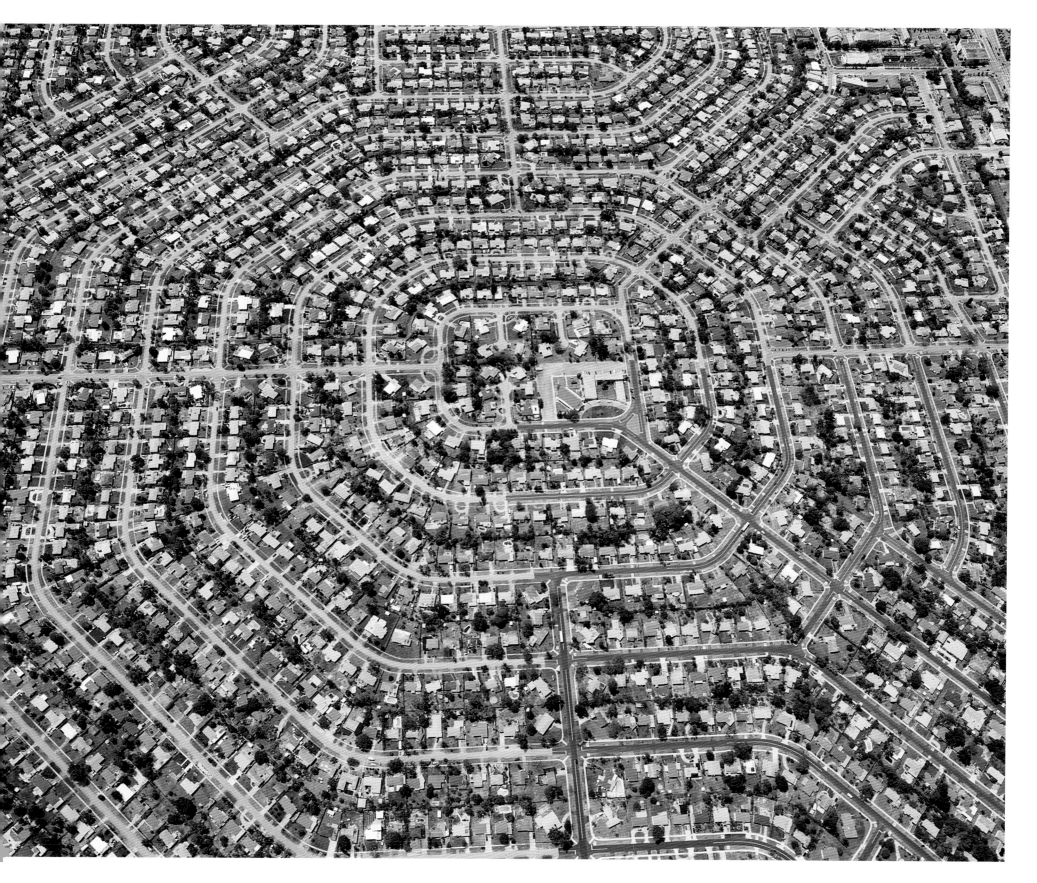

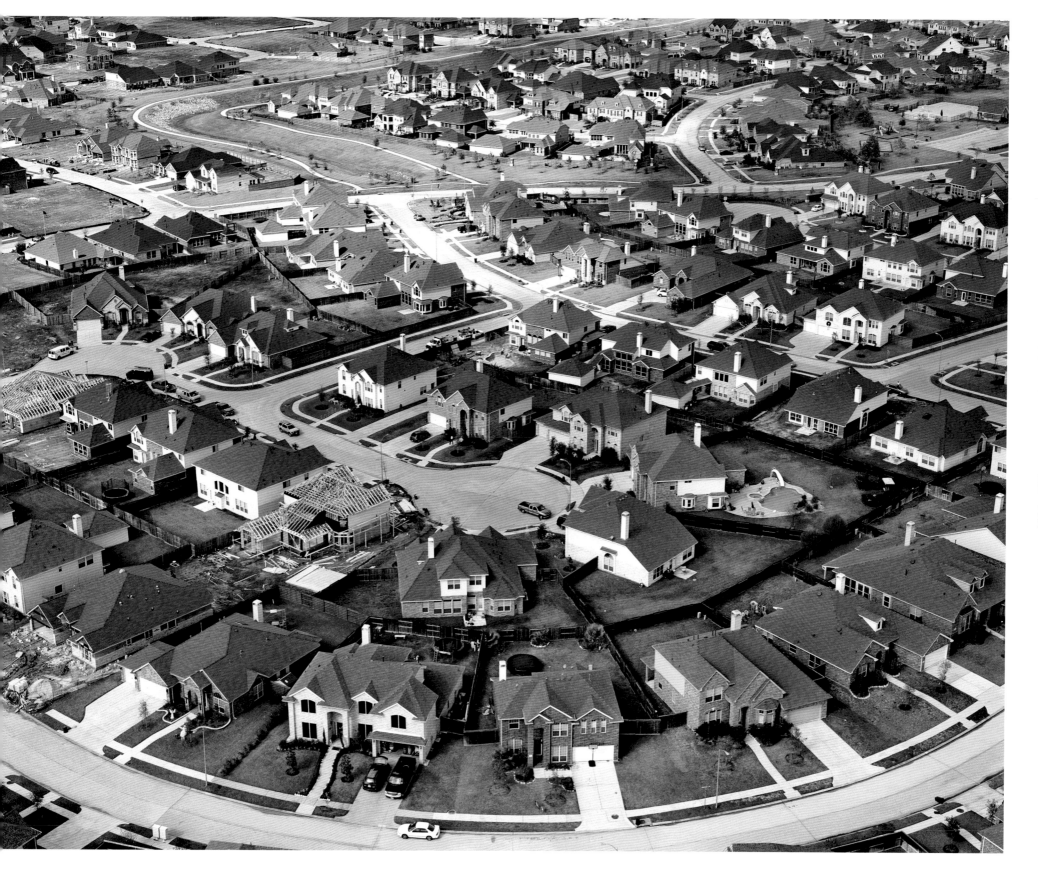

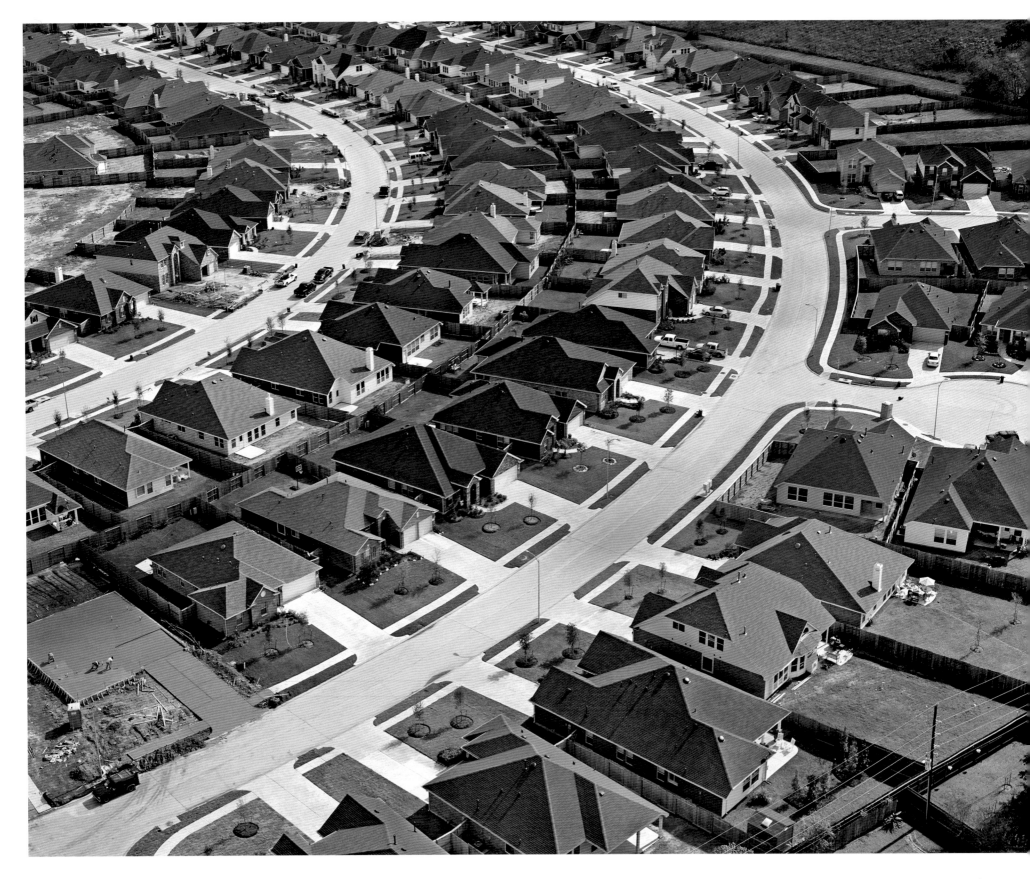

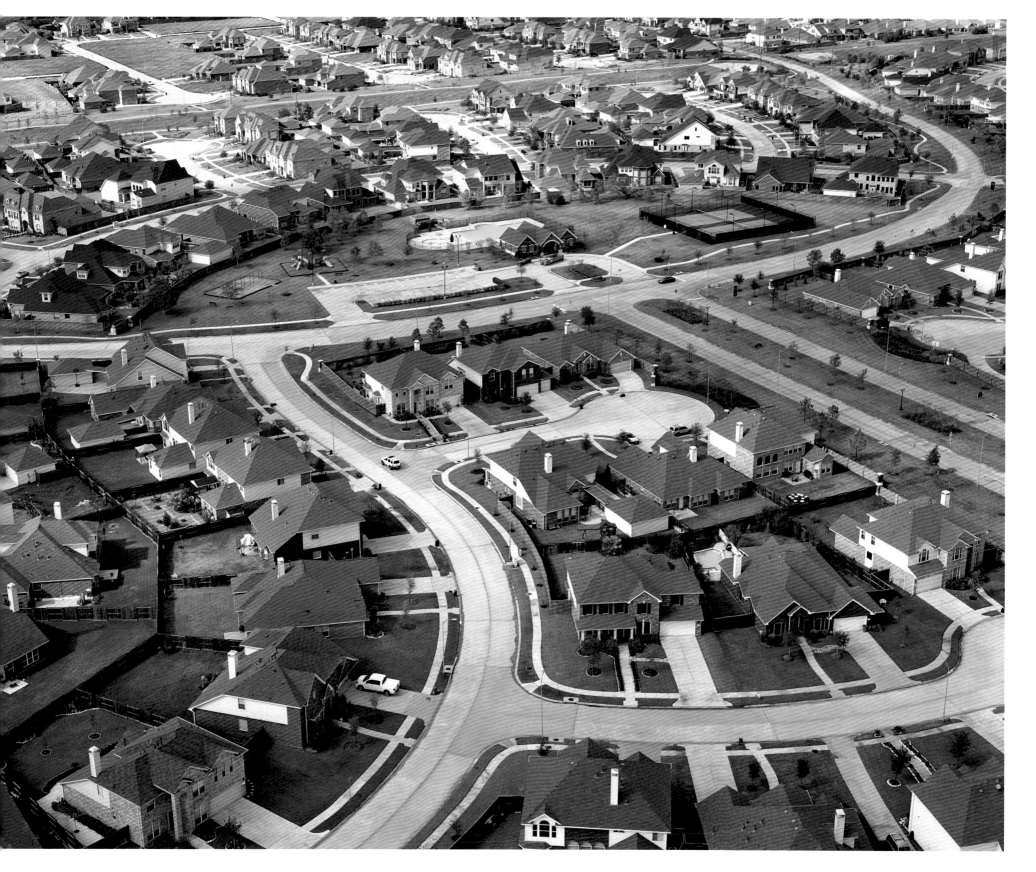

PRELUDE XXI / XXII Urban China

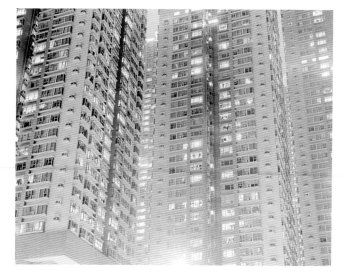

DEER CREST AND BLOOMING GARDEN Christoph Gielen's Social States of Nature

Christoph Gielen's photographs document postwar urban development on three continents, raising universal questions about the social nature of our world. To expose the macrostructures of city planning, Gielen takes a long view. From high above in a helicopter, he focuses on housing schemes, construction landscapes and traffic arteries. The distance imposes an aestheticizing process on the formal patterns in urban structures and ways of life, making them appear as blocks and wedges, cylinders and curves. Yet at the same time, he reproduces residential culture in a different mode of seeing.

Early photographic discourse—including the high point of photography theory—held a primary fascination with photography as a "visibility device" capable of making the invisible visible. The camera could discern what was hidden to the human eye. The "optical unconscious" (Walter Benjamin) was to become perceptible and, for many, photography was the medium that might hold out the potential promise of communicating with the dead or seeing spirits. Gielen's work aims at awakening our awareness of the spatial order underlying social structures. In this case, while photography

may not be the means to raise the dead, it nonetheless becomes an optical device capable of revealing the fundamental structures of our social ideology.

One key feature of an ideology is the ability to present society as if it were natural and necessary, as if one was not dealing with societal conditions of our own making but with the forces of nature. And, indeed, many aspects of Gielen's work deal precisely with the relationship between nature and society—how residential settlements become inscribed in natural space, and how spatial and social developments themselves appear as natural conditions.

The agenda of avant-garde photography was to reflect an unquestioned culture—the so-called second nature, in the light of a primary nature. Technology and nature, the environment and society, were systematically superimposed. This was an approach accompanied by an optimistic aesthetic avowal of faith in a technological civilization. The cover of Albert Renger-Patzsch's *Die Welt ist schön* (*The World is Beautiful*) was adorned by a vignette juxtaposing an electricity pylon with a tree mirroring the same structure. Karl Blossfeldt found art archetypes in the morphologies of mod-

ern technology. In *Raum, Zeit und Architektur* (*Space, Time and Architecture*), Siegfried Giedion, a leading disseminator of modernist urban planning (especially Le Corbusier's), produced a book enthusing over acceleration and mobility. In that spirit, his book cover displayed a highway interchange.

Under late modernist auspices, that same highway interchange returns in Gielen's work. Gielen depicts intersections as proliferating, disorienting structures, surrounded by wasteland (*Conversions XXIII / XVIII / XVII / Suburban California*). Here, he highlights a perspective that was only implicit in early modernism: on closer inspection, the hope that industrialized modernity could have become a natural home was already evident as a duality in the visual language of avant-garde heroes.

On the one hand, the analogy of nature and culture signaled the hope of people becoming just as much at home in a technical civilization as a snail in its shell. On the other, modern culture's likeness to nature also brought out its mythological features: where society presents itself as nature, it can never meet the demands of an enlightened world to be shaped by human beings consciously, equitably, and

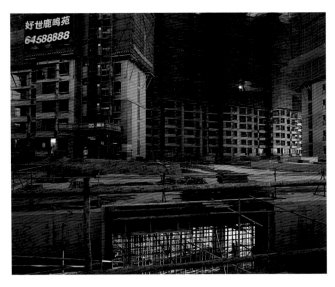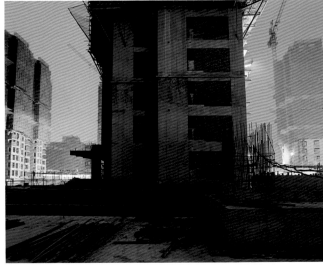

PRELUDE XI/XXVIII Shanghai

responsibly. However, the monumental grandeur of modernity—the highway junction on Giedion's book cover hinted at it—also confronts humankind with a technological civilization that appears massive and foreign. To that extent, nature is always a puzzle image of the familiar and the uncanny—of a naturally grown feeling of belonging, and alienation.

The abstraction in the aerial perspective of housing developments constantly reveals new morphologies, which would otherwise remain hidden in everyday life. The density and concentration of houses evokes associations with scaled armor plates (*Untitled II / XI / X Nevada*) and, hence, also has a message about a societal praxis where residential space serves as a protective shelter and as a fortified area. The fundamental form in modern architecture is the individual armored scale or, more classically, the cell unit—as in Corbusier's *machines for living*—where the form also expresses abstract isolated subjectivity. Cells facilitate a paradoxical duality; they create the appearance of individual self-actualization, yet combine it simultaneously with the maximum of control and uniformity. This is the arcane societal knowledge in Gielen's documentation of standardized individual homes—above all in *Outer Houston II / III / I Texas.*

With their armor scale structures, Gielen's aerial perspectives also expose architectural forms that correlate with the struggle for self-preservation against a seemingly hostile environment (from first and second nature). Pris-

ons (*Untitled XV / XVII / XVIII Arizona*) and fortified residential zones (*Untitled IV / V / XII Nevada*) appear so similar as to be indistinguishable. They are fenced in and built into the dusty landscape with no green areas—harsh exclaves in an inhospitable climate. While Michel Foucault spoke of the concept of the prison as containing a framework of modern subjectivity, the images of self-chosen residential cells and gated communities in Gielen's works seem to provide the proof of it.

The hostility against "the environment" functions morphologically in both directions. It is not only expressed as a struggle against—and separation from—a hostile environment, but at the same time as a pathogenic irritation on the landscape's external surface. Where the housing developments do not resemble armored scales, they appear to be craters or ulcers (*Eden Prairie IV / I / II Florida; Untitled VI / VII / VIII Nevada*), or epitomize space stations on unfamiliar planets (*Sterling Ridge, Florida* series). In this sense, settling always means occupying foreign territory. That concept characterizes the genealogy of colonization on the North American continent. And perpetuating cultural forms of expression somehow belongs to this dialectic, however outdated their economic and technical necessity may have become. Gielen records structures of prosperity in a technically highly developed society that are, almost without exception, only threatened by man-made catastrophes—oil disasters and mortgage crises.

The degree of artificiality in documenting the residential developments is formally interesting. One might imagine that the residential areas with the fewest patches of shade have the highest levels of sheer artificiality (*Untitled I / III / IV / VII / VIII / XI Arizona*). There might even be something to this approach in terms of energy policy: land development in dry, desert-like regions comes with a substantial ecological price tag.

In addition to the topographical dimension and a contentious aesthetics of landscapes, Gielen's images also portray an Urbanity where the city structures and highways appear as semiotic structures, as signs. Aesthetic signs are signs without a primary communicative function. In that sense, Gielen's images can certainly be understood as reflexive art. His views from above make spatial designs appear as messages—particularly in the *Former East Sector and Peripheral Berlin V / VI / III Germany* series from the margins of Potsdam and Berlin—or secret codes, given a fascinatingly mysterious character. But precisely because these textures of a built-up society are illegible, the constructed world—our second nature—also appears uncanny. They can be compared to hieroglyphs, inscribed more for Ancient Egyptians or extra-terrestrials than for their real inhabitants.

This raises the question of whether the urban structure of social life is not beyond transparent rationality and democratic control as well—in other words, whether spatial cultures are not also structurally alienated from the societal

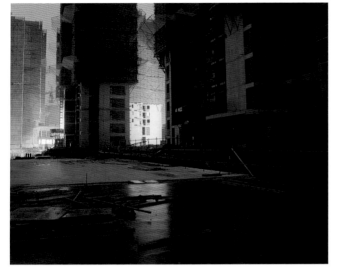 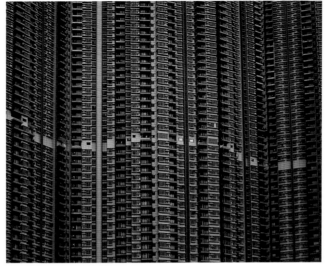

practice in which they are embedded. To that extent, Gielen's use of distance has both a reflexive aesthetic dimension, as well as a heuristic and critical one. Gielen becomes a stranger, his camera methodically ceasing to understand the world so that the world can become visible in other ways.

After all, when the pattern of human settlements and colonies become visible from the air, the social structures become mysterious.

Urban planning is the formal axiom of society that most explicitly voices the question of a society's principles of meaning. In Gielen's work, the massive collective building blocks of "real socialism" (*Former East Sector, Germany* series) stand in contrast to the schematic lot divisions of property ownership (*Outer Houston, Texas;* and *Forest Glen, Suburban California* series) and apathetic mass dwellings (*Impervious Surfaces, Bronx*), that represent non-integrative city planning. Private investors become the planners of a world determined by private economic interests.

The Athens Charter formulating—under Giedion and Le Corbusier—a minimal program for urban design proclaimed the connection between living, transport, work, and the (socially understood) prospects for leisure. In Gielen's US residential zones, the last two of these remain unconnected, unseen. Public ownership and a socialization of space, of public life, does not take root in this system of infinite individual liberties. Ironically, this may in turn produce individuals that are collectivized. Ways of life, con-

sumer behavior, types of buildings and lifestyles in the parceled-out realm of personal property look absolutely identical—lot after lot, the same bay window, the same garden fence, lawn mower and swimming pool, and the same TV program. Social controls can indeed remain invisible wherever society in an emphatic sense has been run down by privatization. The lot itself is the control.

Against this suburban setting, Gielen's photos of real socialist housing—which failed as an overarching project— hold out a certain attraction and promise. It is the alternative project to the logic of sprawl and unplanned urban development in the suburbs. This alternative promise is hidden in the schematic semiotic character of urban design. Series of letters appear discernible in the residential blocks—C, G, perhaps even an O—as if they reflected a rational structure, a code and a concept that socialized people to plan. Even if the textual logic of this plan can no longer be decoded—we have, in a certain sense, likewise become Ancient Egyptians when it comes to the socialist plan—something remains in the patterns that allows for a question about a societal rationality: what would constitute a rational perspective on the spatial organization of human ways of life?

One can hardly fail to notice the question's deductive and subsumptive character—the monumental architectural forms are reminiscent of building blocks in some enigmatic master plan where the individuals, scaled down beyond recognition, mutate into the switch points of giant micro-

chips—a surprising analogy, but one forcefully suggested by Gielen's images.

Siegfried Giedion and modernist city planners enthused over the idea of structuring the world rationally. On the one hand, and this is how most people are likely to spontaneously respond, as a prescribed central solution forming part of a radical, socialist regimen, this rationality becomes suspect and takes on the character of a mythical force—a closed system with no way out. In its contrary image, on the other hand, in the lot-based residential form documented by Christoph Gielen as the American dream/nightmare, social planning is avoided—yet this also reintroduces it, in a variety of ways, as a state of nature. Not merely are the artificially constructed residential areas given the appearance of naturalness (*Thousand Oaks, Deer Crest, Forest Glen*—names used for the profusion of own home areas), but viewed from the air, they resemble natural structures: honeycombs or Muschelkalk sediments. Society coheres with nature.

Ironically, the honeycomb metaphor brings us full circle. In the early stages of liberalist theory, Dutch philosopher Bernard de Mandeville wrote his "Fable of the Bees" (1714) in England. The poem was founded on the idea of the swarm of private interests ultimately sufficing to ensure public benefit (private vices—public benefit). The hive was the primary metaphor.

But this mythology hardly retains the power to convince nearly three hundred years later, when the divi-

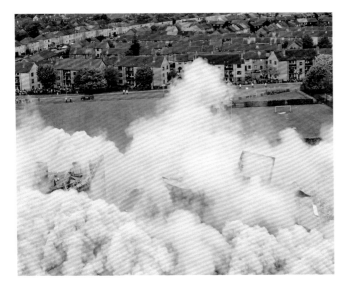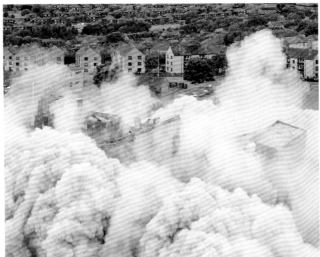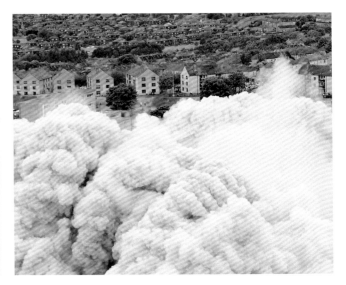

PRELUDE III / I / II Urban Scotland

sion of wealth has been increasingly polarized across the world, the ecological capacities pushed to their limits, and the economic logic of crises becomes apparent not only to mortgage traders. And yet the "Fable of the Bees" has survived as a mythological layer in (neo)liberalism. These are the structures revealed in the land-use planning of the American dream—and this mythological base-layer of atomized small-scale home owners is perfectly displayed in the character of the parceled residential districts of southern California.

From Gielen's perspective, his narrative of this urban (il)logicality has no open horizons and indeed, in a certain sense, displays a total lack of perspective. His top views contain no sky, no undeveloped spaces and no room for alternatives. Since his critical approach demands a distanced perspective—and, hence, to a certain degree, is a view from the other side—it only underlines the fateful and catastrophic nature of urban development where ecological sustainability and utility for society as a whole are evidently not valid categories.

Gielen documents from a different perspective—he photographs "topoclastic" scenes (*Urban Scotland* series) of creative destruction giving his images a dual character. They disclose the destructive logic of urban planning that excludes building-to-last as a criterion, a type of planning that incorporates their inevitable demolition right from the start.

And yet, this may be the substantive reason for the choice of perspective—the demolition of mis-developments also brings us down to earth and, thus, reveals possibilities. The *tabula rasa of destruction*—where the gray-white surfaces of smoke and dust echo the photographic paper's tabula rasa—open up a space for possibilities.

Gielen chooses the same ground perspective in his photographs of east Asia, which, referencing a different political planning model, launch a new thematic block. Here, he finds himself with both feet firmly on the ground, surrounded by strangely lit construction landscapes, gleaming in a brilliant, cold green, yellow, or a cosmic blue. In these works, the open horizons sometimes correspond to a standpoint in the center of events. Here, construction sites and major projects appear without contrast to landscape—the planning and construction designs are, as it were, left to themselves. At the same time, the megalomania in the power of construction is again characterized by a strange (and estranging) grandeur, which is most reminiscent of the power of raw nature (*Prelude, Urban China* series).

Admittedly, here Gielen is also a stranger, and the construction sites are similarly moon landscapes, space stations, and ghost towns. But Gielen is a stranger who finds himself on the ground where history is being made, where the process is ongoing. This development may indeed be fearsome, but it is not yet concluded and has an open per-

spective: China is a focal point, both for Gielen and generally for the present political and urbanist discourse of modernization. There can be no doubt that China is increasingly drawing the economic, and possibly the cultural and political, focus of the coming decades. As a result, China in particular confronts the Western world with the devastating implications of modernity as if in fast-forward. The West is beginning to fear about China what it itself has long since done to the world. In this way, China's development is the mirror of a Western model of progress, and offers a space for anyone to project a bad conscience onto it.

In the view of architects and urbanist theorists such as Rem Koolhaas after the end of a confident urbanism, China also becomes a challenge for reconsidering the development of urban design and the architectural-spatial perspectives of a global society. And that leads to the question of where the Great Leap Forward Mao had promised is supposed to lead. What is the plan?

China is a textbook case because China is catching up on what the West did first. Under the dominance of this dynamic of development, the world is becoming infinitely similar. Just as in the parceled landscapes of residential property in California and Texas, the architectural complexes in Shanghai, Shenzhen, and Chongqing also often cultivate the appearance of naturalness. They are called "Blooming Garden" or "Bamboo River."

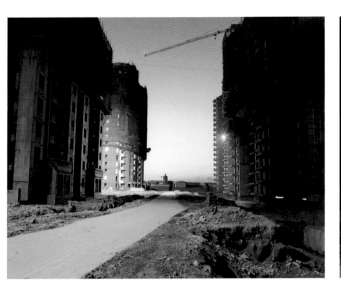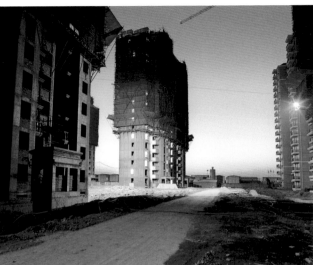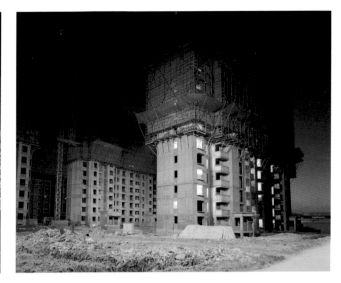

A world dominated by unbridled construction does not only become more similar. First and foremost, it becomes small. In all of Gielen's works, the world is densely populated where, as already mentioned, there is hardly space left for the unanticipated. Precisely in this sense, his images are snapshots of a global society where the issue of rational orientation is the burning question of the moment. Because the world has become small, the question of its meaningful design urgently needs to be answered everywhere.

However, after the latest global crisis directly linked to the home-ownership lifestyle, there seems little hope that—unlike the bees in a hive—things will take a reasonable course if left to their own natural devices. It can hardly be assumed that the laws of nature governing market-designed modernization are capable of showing improvement on their own. "As long as the world follows its logical course," wrote Max Horkheimer in the 1940s, "it fails to fulfill its human destiny."

Johan Frederik Hartle

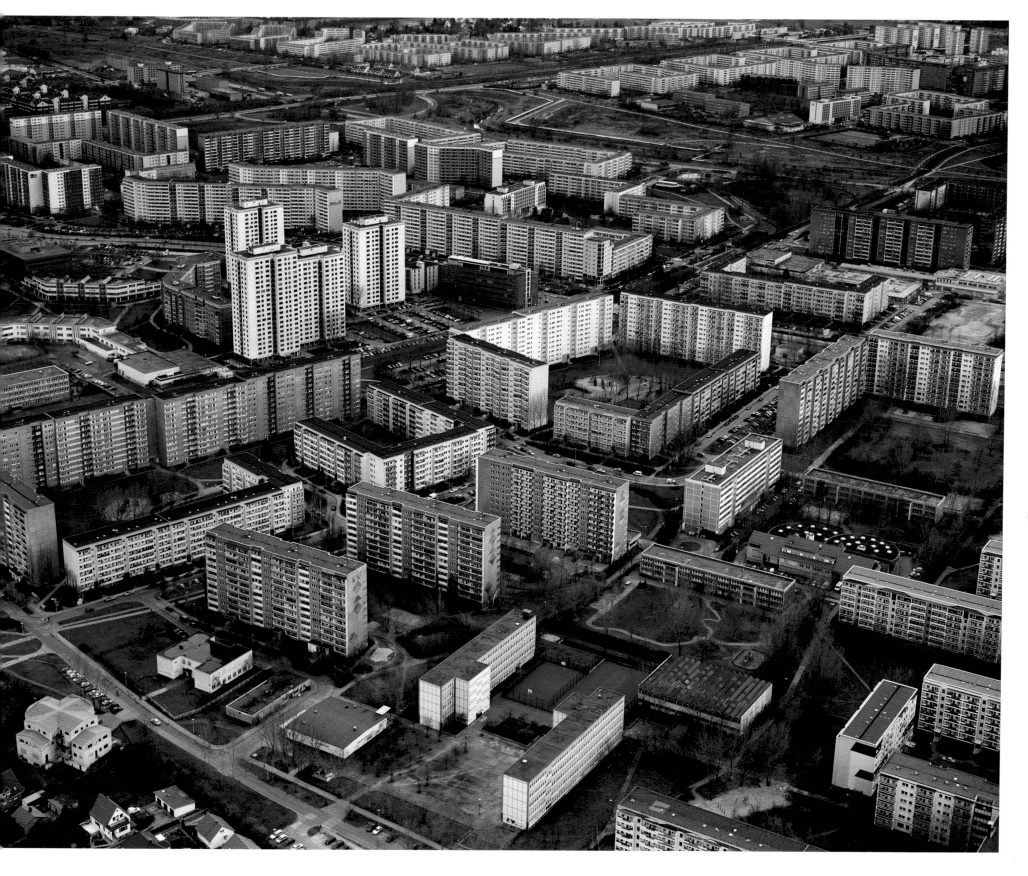

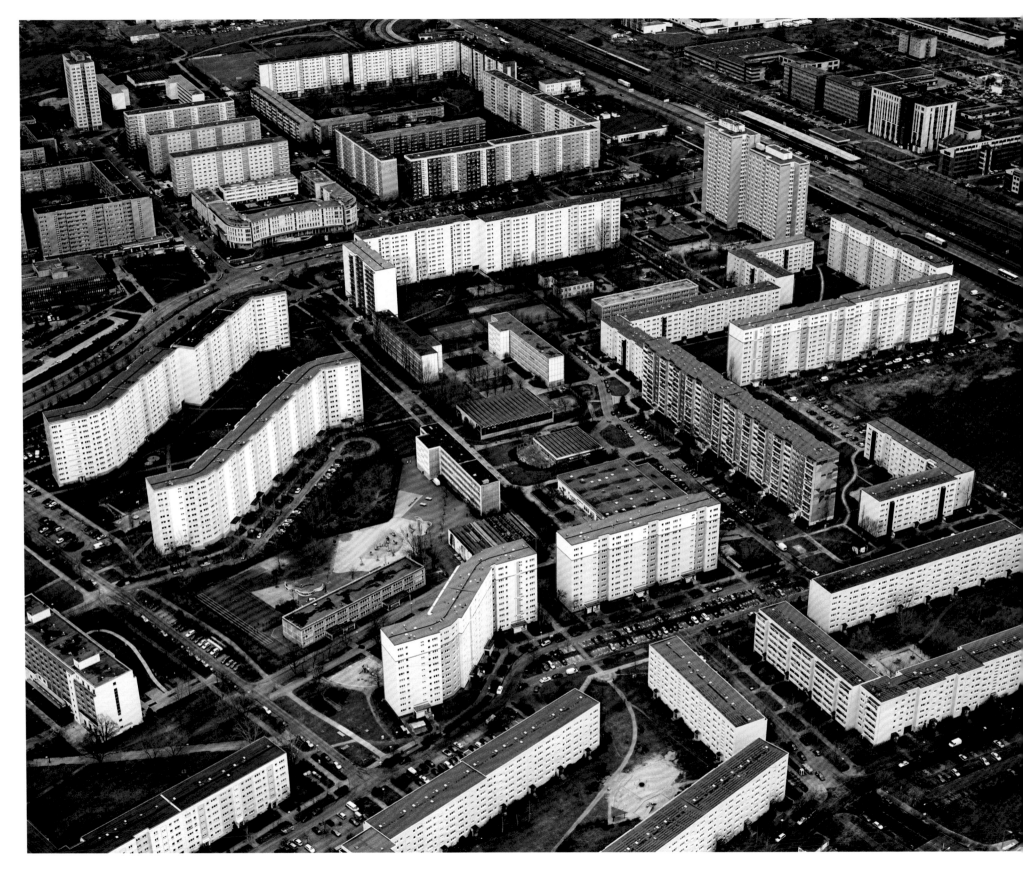

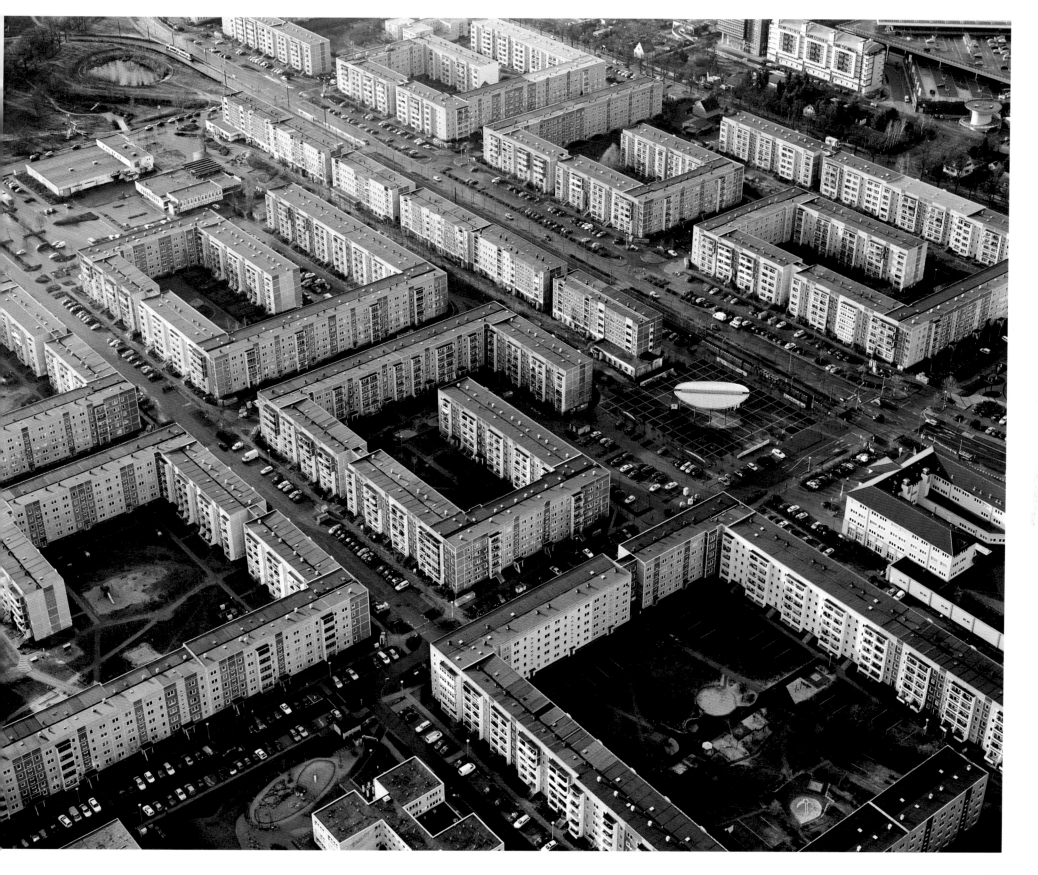

APPENDIX: ILLUSTRATION DETAILS

All photographs for Ciphers were made between 2003 and 2010 using analog film, and taken in the United States, Scotland, the former German Democratic Republic, as well as in central and south China.

pages 6/7
Untitled California IV
Simi Hills, Ventura County, California

pages 6/7
Untitled California III
Wood Ranch Reservoir, Ventura County, California
developer: A.A. Baxter Corporation, construction: 1964

page 8
Subtropical Watershed IV Florida
Everglades National Park, Collier County, Florida
established in: 1947

page 9
Subtropical Watershed II Florida
Everglades National Park, Monroe County, Florida
established in: 1947

Subtropical Watershed III Florida
*Everglades National Park, Monroe County, Florida
established in: 1947*

page 10
Drought II Florida
Everglades National Park, South Collier County, Florida
established in: 1947

Drought IV Florida
Everglades National Park, South Collier County, Florida
established in: 1947

Drought I Florida
Everglades National Park, South Collier County, Florida
established in: 1947

page 11
Drought Florida
The Everglades, Monroe County, Florida
established in: 1947

page 13
UNTITLED VI Arizona
Sun City, Maricopa County, Arizona
development and design: Del E. Webb
construction: late 1950s

page 14
UNTITLED XXVIII Arizona
Sun City, Maricopa County, Arizona
development and design: Del E. Webb
construction: late 1950s

page 15
UNTITLED IXXX Arizona
Sun City, Maricopa County, Arizona
development and design: Del E. Webb
construction: late 1950s

page 17
UNTITLED II Nevada
Anthem, Henderson, Clark County, Nevada
development and design: Del Webb, construction: 1995

page 18
UNTITLED X Nevada
Anthem, Henderson, Clark County, Nevada
development and design: Del Webb, construction: 1995

page 19
UNTITLED XI Nevada
Anthem, Henderson, Clark County, Nevada
development and design: Del Webb, construction: 1995

page 21
UNTITLED VII Nevada
Summerlin, Las Vegas, Clark County, Nevada
developer: The Howard Hughes Corporation
construction: 1990s

page 22
UNTITLED VIII Nevada
Summerlin, Las Vegas, Clark County, Nevada
developer: The Howard Hughes Corporation
construction: 1990s

page 23
UNTITLED VI Nevada
Summerlin, Las Vegas, Clark County, Nevada
developer: The Howard Hughes Corporation
construction: 1990s

page 25
STERLING RIDGE VII Florida
Rotonda West, Charlotte County, Florida
developer: Cavanagh Communities Corporation
construction: 1973

page 26
STERLING RIDGE III Florida
Rotonda West, Charlotte County, Florida
developer: Cavanagh Communities Corporation
construction: 1973

page 27
STERLING RIDGE VI Florida
Rotonda West, Charlotte County, Florida
developer: Cavanagh Communities Corporation
construction: 1973

page 29
UNTITLED X Arizona
Sun Lakes, Maricopa County, Arizona
development and design: Ed Robson / Robson Communities, construction: 1970s

page 30
UNTITLED XII Arizona
Sun Lakes, Maricopa County, Arizona
development and design: Ed Robson / Robson Communities, construction: 1970s

page 31
UNTITLED XI Arizona
Sun Lakes, Maricopa County, Arizona
development and design: Ed Robson / Robson Communities, construction: 1970s

page 33
FOREST GLEN III California
Village of Heritage, Fontana, San Bernardino County, California
developer: Hall & Foreman, Inc., design: Jess Harris, LandPlan Design Group, construction: 1987

page 34
FOREST GLEN VI California
Village of Heritage, Fontana, San Bernardino County, California, developer: Hall & Foreman, Inc.
design: Jess Harris, LandPlan Design Group
construction: 1987

page 35
FOREST GLEN I California
Village of Heritage, Fontana, San Bernardino County, California
developer: Hall & Foreman, Inc., design: Jess Harris, LandPlan Design Group, construction: 1987

page 37
UNTITLED VIII Arizona
Sun City, Maricopa County, Arizona
development and design: Del E. Webb
construction: late 1950s

page 38
UNTITLED VII Arizona
Sun City, Maricopa County, Arizona
development and design: Del E. Webb
construction: late 1950s

page 39
UNTITLED XXI Arizona
Sun City, Maricopa County, Arizona
development and design: Del E. Webb
construction: late 1950s

page 40
Untitled California II
Interstate 5 interchange (I-5 / Route 14 / San Fernando Road), San Fernando Valley, Los Angeles County, California
developer: State of California Business and Transportation Agency, Department of Public Works, Division of Highways, construction: 1977

page 41
CONVERSIONS XXIII Suburban California
Interstate 15 interchange (I-15 / SR-210), San Bernardino County, California
developer: State of California Department of Transportation, architect: E.L. Yeager Construction Co.
construction: 2002

page 42
CONVERSIONS XVII Suburban California
Interstate 15 interchange (I-15 / SR-210), San Bernardino County, California
developer: State of California Department of Transportation, architect: E.L. Yeager Construction Co.
construction: 2002

page 43
CONVERSIONS XVIII Suburban California
Interstate 15 interchange (I-15 / SR-210), San Bernardino County, California
developer: State of California Department of Transportation, architect: E.L. Yeager Construction Co.
construction: 2002

page 45
SKYE ISLE I Florida
Island Walk, Four Seasons, Collier County, Florida
development and design: DiVosta, construction: 1998

page 46
SKYE ISLE III Florida
Island Walk, Four Seasons, Collier County, Florida
development and design: DiVosta, construction: 1998

page 47
SKYE ISLE II Florida
Island Walk, Four Seasons, Collier County, Florida
development and design: DiVosta, construction: 1998

page 48
Untitled Nevada
Summerlin, Las Vegas, Clark County, Nevada
developer: The Howard Hughes Corporation / Summa
construction: 1990s

page 49
two diagrams illustrating a tract-housing redevelopment strategy by Galina Tachieva, Duany Plater-Zyberk & Company

page 51
CONVERSIONS Urban California
Interstate 15 interchange (I-15 / SR-210), San Bernardino County, California
developer: State of California Department of Transportation, architect: E.L. Yeager Construction Co.
construction: 2002

Interstate 5 interchange (I-5 / Route 173 / 60 / 101)
Los Angeles County, California, developer: State of California Transportation Agency, Department of Public Works, Division of Highways, construction: 1961–1969

Interstate 405 interchange (Route 90 / I-405), Los Angeles County, California, developer: State of California Transportation Agency, Department of Public Works, Division of Highways, construction: 1967

pages 52/53
Untitled California V
Van Nuys, Los Angeles County, California
various developers, construction: 1911 – present

page 55
UNTITLED XII Nevada
Spring Valley, Enterprise, Clark County, Nevada
developer: Rhodes Ranch Master Planned Community
construction: 2004

page 56
UNTITLED IV Nevada
Spring Valley, Enterprise, Clark County, Nevada
developer: Rhodes Ranch Master Planned Community
construction: 2004

page 57
UNTITLED V Nevada
Spring Valley, Enterprise, Clark County, Nevada
developer: Rhodes Ranch Master Planned Community
construction: 2004

page 59
UNTITLED I Arizona
Venture Out RV Resort, Mesa, Maricopa County, Arizona
developer: Busby Associates Limited
construction: 1968

page 60
UNTITLED III Arizona
Venture Out RV Resort, Mesa, Maricopa County, Arizona
developer: Busby Associates Limited
construction: 1968

page 61
UNTITLED IV Arizona
Venture Out RV Resort, Mesa, Maricopa County, Arizona
developer: Busby Associates Limited
construction: 1968

page 62
Untitled California I
Thousand Oaks, Ventura County, California;
developer: Janss Investment Company
construction: 1950s

APPENDIX: VIDEO DETAILS

Video footage was shot from a helicopter in collabora-
tion with cinematographer Michael Kelem (BBC's
"Planet Earth" series), utilizing a cineflex hi-definition
video system developed for "Planet Earth".

pages 6/7
Untitled California IV
Simi Hills, Ventura County, California

This sequence shows an arid Simi Hills territory in eastern
Ventura County and the Thousand Oaks region north of
the Santa Monica Mountain range already slated for home
development—a high-risk region known to be prone to
wildfire. (This footage was made during weather conditions
conducive to wildfire.) These fires can grow to engulf more
than 16,000 acres (65 km²) in blazes that annually threaten
homes, natural resources, power lines, and communica-
tions equipment. Ensuring personal safety and meeting
reasonable home insurance coverage apparently don't
suffice to deter development in this area.

pages 6/7
Untitled California III
Wood Ranch Reservoir, Ventura County, California

This sequence shows the water surface of the Wood Ranch
Reservoir as it is manipulated by the rotor blades of our
hovering helicopter.

In contrast to other development projects in arid regions,
which often depend on far flung water supplies—such as
Las Vegas and its satellite developments drawing on Lake
Mead in Nevada—Wood Ranch is an example of an ade-
quately managed water supply system. But typically, more
exclusive settlement clusters in such landscapes require
large water feeds not just for basic subsistence in loca-
tions that are geographically unsuited for development,
but for maintaining golf courses, or elaborate, decorative
water features. Filming here was meant to call attention
to these water management–related challenges and to the
notion of water as an essential resource.

page 40
Untitled California II
Interstate 5 interchange (I-5 / Route 14 / San Fernan-
do Road), San Fernando Valley, Los Angeles County
California

This junction sits in the middle of a thirty-mile segment of
the Interstate 5 freeway known in the greater Los Angeles
region as the "Interstate 5 corridor" or "Business loop 5".
It is a major traffic artery wedged in between Glendale and
Burbank on one side and Santa Clarita on the other. The
San Fernando Road, Old Road, and I-5 can be seen in this
shot sequence as they pass through rock quarries and one
of the last remaining open spaces in the San Fernando
Valley. This traffic "Interstate 5 corridor" axis links all of
the surrounding regional developments, and serves as a
text-book case of American car-centric land development.

page 62
Untitled California I
Thousand Oaks, Ventura County, California

This small, master-planned city section in Conejo Valley
is part of an expansive development stretch that has been
settled to accommodate a large population at a fast pace.
By the 1960s and 1970s, orthogonal grid designs were out
and many residential community master planners had
turned to centralized circular or polygonal geometric pat-
terns as an alternative, especially when building on fields
that didn't need to plug into preexisting street patterns.

pages 52/53
Untitled California V
Van Nuys, Los Angeles County, California

The night cityscape of Van Nuys is shown here in sweeping
camera motions, panning outward to reveal the expanse
of the region. The San Fernando Valley has been termed
"America's suburb," and could be seen as one of the birth
places of the suburbia endeavor. Van Nuys was settled by
the Los Angeles Suburban Home Company in 1911, a time
when California held a particular promise and draw. Van
Nuys Boulevard was once termed "Auto Row," as it is still
known today for its high concentration of car dealerships.

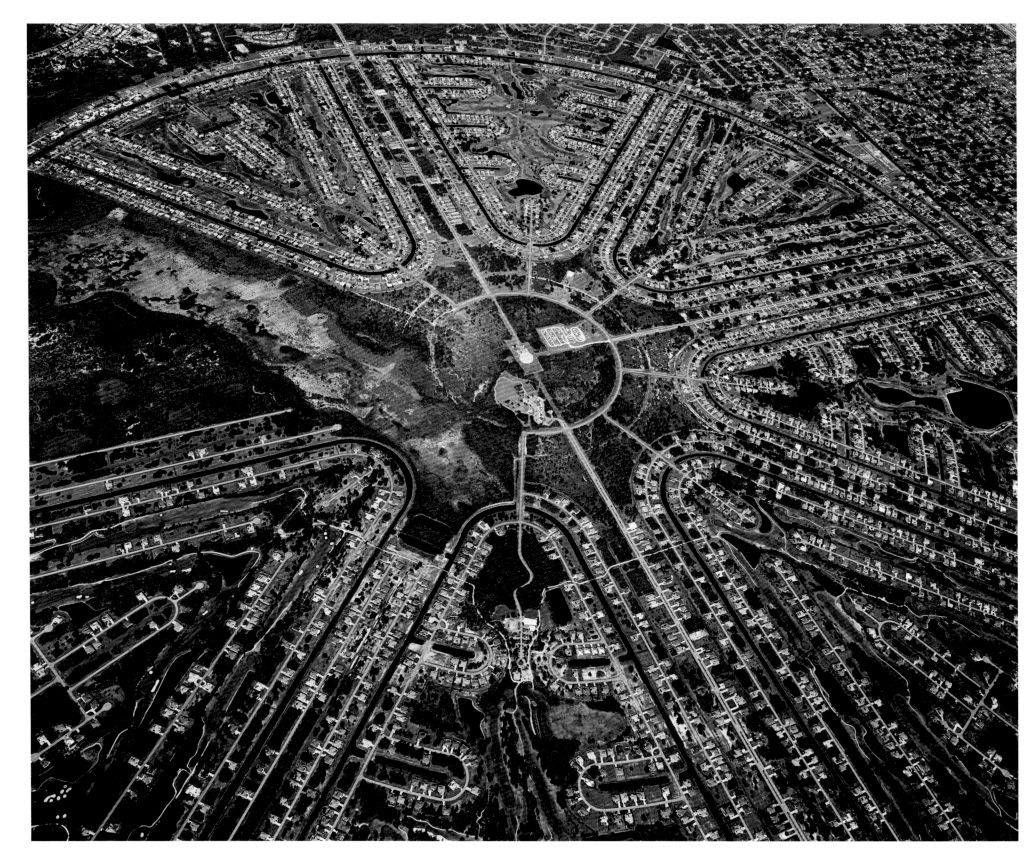

BIOGRAPHIES

Christoph Gielen is a photographer who specializes in exploring the intersection of art and environmental politics. Gielen's award-winning work has been featured at TEDtalks and at the BMW Guggenheim lab, extensively published, and exhibited internationally.

Contributing Authors

Johan Frederik Hartle, Dr. phil., is Assistant Professor for Philosophy of Art and Culture at the University of Amsterdam (UvA). His areas of expertise are the aesthetics of space, institutional theories of art, and the repercussions of Marxism in cultural and aesthetic theory. Hartle is the author of *Personal Kill*, and *DADALENIN*.

Journalist and curator **Geoff Manaugh** believes that design possibilities can be found everywhere. He is the author of BLDGBLOG, and the editor-in-chief of the technology blog *Gizmodo*. The former director of Studio-X NYC, an urban futures think tank run by the architecture department at Columbia University, teaches and lectures extensively at museums and design schools around the world. The *BLDGBLOG Book* was published in 2009.

Susannah Sayler and **Edward Morris** cofounded The Canary Project in 2006, a collaborative that produces visual media and artworks that deepen public understanding of climate change. Works from The Canary Project have been exhibited in public spaces and international museums. Sayler and Morris, both 2008–2009 Loeb Fellows at Harvard University's Graduate School of Design, currently teach in the Transmedia Department at Syracuse University.

Galina Tachieva is a partner at Duany Plater-Zyberk & Company, Architects and Town Planners. With her expertise in urban redevelopment, sprawl retrofit, and form-based codes, Tachieva is also a leader of the Congress for the New Urbanism Sprawl Retrofit Initiative, as well as a founding member of the Congress for European Urbanism. She is the author of the *Sprawl Repair Manual*.

Architect and theorist **Srdjan Jovanovic Weiss**, PhD, practices research and design as a singular genre of architecture. He is the principal of NAO (Normal Architecture Office) and cofounder of School of Missing Studies, an experimental study of cities marked by abrupt transition. He has taught at Temple University's Tyler School or Art_Architecture, the Harvard Graduate School of Design, Cornell University, and at The University of Pennsylvania School of Design, and is the author of *Almost Architecture*, and *Socialist Architecture: The Vanishing Act*.

ACKNOWLEDGMENTS

This project has been generously sponsored by the Aaron Siskind Foundation and by Furthermore: a program of the J.M. Kaplan Fund.

Without the following individuals, Ciphers would not have materialized.

My heartfelt thanks to: Bruce Babbitt, Heike Bachmann, Peter Barbur, Juliana Beasley, Beatrix Birken, Peter Bitzer, Andrew Boreham, Jutta Bornholdt-Cassetti, Norma Jean Bothmer, Todd Bradway, John Burton, Stacey Clarkson, Sebastian Collett, Tim Doody, Mitch Epstein, Azmi Mert Erdem, William Ewing, Peter Fahrni, Keitha Fine, Jonas Fogel, David Frey, Franziska Fritzsche, Natalie Gaida, Andreas Gefeller, Beate Geissler, André von Graffenried, Robert Hammond, Jess Harris, Johan Frederik Hartle, Linda Hasselmann and the helpful staff at ROBERTNEUN, Daniel Heer, Nathalie Herschdorfer, Sarah Holland, Tom Hurley, Nina Katan, Marisa Mazria Katz, Nicole Katz, Michael Kelem, Mitch Kelldorf, Marla Hamburg Kennedy, Cleveland Kersh, Matthew Knight, Aleksandre Kourako, Lola Kourako, Niels Lanz, Kevin LaRosa, Joanna Lehan, Jon Letman, Andy Lim, Geoff Manaugh, Esteban Mauchi, Edward Mazria, Dan McBride, Abraham McNally, Daniel McPhee, Charles Montgomery, Nate Mook, Edward Morris, Peter Muennig, Sarah Palmer, Owen Pritchard, Michael Prokopow, Maria Raptis and the helpful staff at the California Department of Transportation, Nina Reznick, Philine Rinnert, Clay Risen, Susanne Rösler, Oliver Sann, Susannah Sayler, Tom Schaus, Al Sousa, Philipp Sperrle, Tema Stauffer, Celina Su, Galina Tachieva, Anne Coleman Torrey, David Troy, Robyn Turner, Scott Urschel, Jochen Visscher, Tara Wefers, Srdjan Jovanovic Weiss, June Williamson and Irina Woelfle.

And deep gratitude goes to my reliable family base: Christa Gielen, Gregor Gielen, and Nina Gielen, and to my designer, the marvelous Julia Braun—making this book was her idea and she brought it to life.

This book was made possible with a grant from:

Furthermore:
a program of the J.M. Kaplan Fund

Cover: UNTITLED I Arizona

Photography: Christoph Gielen
Videography: Michael Kelem, Christoph Gielen
Production Consultant: Nina Gielen
Design and setting: Julia Braun
Scanning: Tom Hurley, Laumont NYC
Imaging: Esteban Mauchi, Laumont NYC
Lithography, printing and binding: GCC Grafisches Centrum Cuno, Calbe

Bibliographic information published by the Deutsche Nationalbibliothek
The Deutsche Nationalbibliothek lists this publication in the Deutsche Nationalbibliografie;
detailed bibliographic data are available on the Internet at http://dnb.d-nb.de

jovis Verlag GmbH
Kurfürstenstraße 15/16
10785 Berlin

www.jovis.de

jovis books are available worldwide in selected bookstores. Please contact your nearest
bookseller or visit www.jovis.de for information concerning your local distribution.

ISBN 978-3-86859-318-1